Art Classics

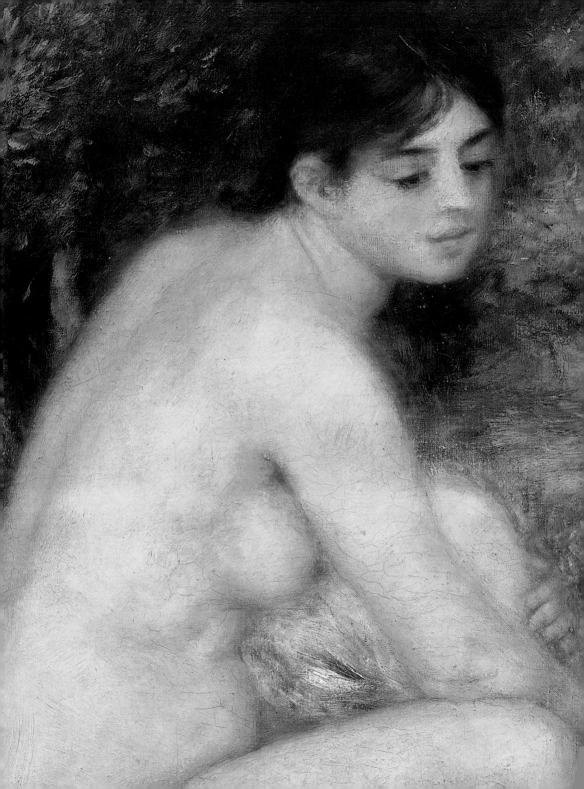

Art Classics

RENOIR

Preface by Jean Renoir

ART CLASSICS

RENOIR

First published in the United States
of America in 2005 by
Rizzoli International Publications, Inc.
300 Park Avenue South
New York, NY 10010
www.rizzoliusa.com

Originally published in Italian by
Rizzoli Libri Illustrati
© 2004 RCS Libri Spa, Milano
All rights reserved
www.rcslibri.it
First edition 2003
Rizzoli \ Skira – Corriere della Sera

2005 2006 2007 2008 2009 /
10 9 8 7 6 5 4 3 2 1

Printed in China

ISBN: 0-8478-2732-1

Library of Congress Control
Number: 2005922007

Director of the series
Eileen Romano

Design
Marcello Francone

Translation
Miriam Hurley
(Buysschaert&Malerba)

Editing and layout
Buysschaert&Malerba, Milan

cover
The Reader
(detail), 1875–1876
Paris, Musée d'Orsay

frontispiece
Nude amid Landscape
(detail), 1883
Paris, Musée de l'Orangerie

The publication of works owned by
the Soprintendenze has been made
possible by the Ministry for Cultural
Goods and Activities.

© Archivio Scala, Firenze

Contents

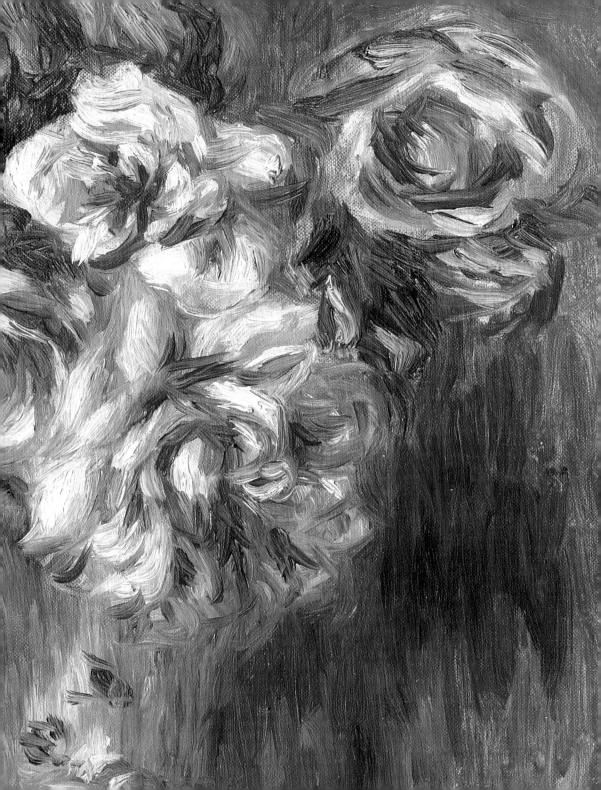

Renoir, My Father
Jean Renoir

In the garden of my house in California there is an orange tree near the kitchen door. I gaze at it and I breathe in its perfume. It is covered with blossoms. I never see an orange tree in flower without thinking of Cagnes. And thinking of Cagnes immediately conjures up the figure of my father. For it was there that he spent the best of his last years; it was there that he died. At his home, Les Collettes, the scent of orange blossoms is still the same and the olive trees have not changed. The grass in particular makes me feel close to him. Though thin, it is tall and wiry, gray, except in winter, composed of the most varied species and sprinkled with the prettiest wildflowers imaginable. Its perfume does not assault your nostrils violently as it does in the wild, stony stretches of land around Aix-en-Provence. It has a more subtle, but an unforgettable, quality. If I were to be taken blindfolded to Les Collettes, I am sure I should recognize it at once just from the scent.

The shadow cast by the olive trees is often mauve. It is in constant motion, luminous, full of gaiety and life. If you let yourself go, you get the feeling that Renoir is still there and that you are suddenly going to hear him humming as he studies his canvas. He is part of the landscape. It does not need much imagination to see him sitting there, at his easel, with his white linen hat half askew on top of his head. His emaciated face wears an expression of affectionate mockery. Except in the last few weeks, the sight of his pitifully thin and paralyzed body did not worry us unduly; Gabrielle and my brother and I were not upset by it, nor

*Roses
in a Vase*
(detail), 1910
Paris, Musée
d'Orsay

7

was anyone close to him. We were accustomed to it, and so was he. Now, with the passage of time, I see him better. Easy comparisons come to mind. In Algiers Europeans will call an old Arab "trunk of a fig tree." In France literary men, who like to affect the speech of the peasants, refer to an old villager as a "vine stalk." These expressions are based on entirely physical analogies. With Renoir, however, they might be carried further, to evoke the abundant and magnificent fruit which the fig tree and the vine produce from stony soil.

My father had something of an old Arab about him and a great deal of the French countryman—apart from the fact that his skin had remained as fair as that of an adolescent, because it was constantly protected from the rays of the sun. He had to keep his canvas away from the reflections of light, which, he declared, "play the devil" with one's work.

What most struck outsiders at first meeting were his eyes and his hands. His eyes were light brown, bordering on amber; and they were sharp and penetrating. He would often point out a bird of prey on the horizon flying over the valley, or a ladybird climbing up a single blade in a tuft of grass. We, with our young eyes, had to look carefully, concentrate and examine everything closely, whereas he took in immediately everything that interested him, whether near or far. So much for the physical aspect of his eyes. As for their expression, they had a look of tenderness mixed with irony, of merriment and sensuousness. They always seemed to be laughing, perceiving the odd side of things. But it was a gentle and loving laughter. Perhaps it also served as a mask. For Renoir was extremely shy about his feelings and never liked to give any sign of the emotion that overpowered him when he looked at flowers, women or clouds—other men touch a thing or caress it.

His hands were terribly deformed. His rheumatism had made the

joints stiff and caused the thumbs to turn inward towards the palms, and his fingers to bend towards the wrists. Visitors who were unprepared for this could not take their eyes off his deformity. Though they did not dare to mention it, their reaction would be expressed by some such phrase as "It isn't possible! With hands like that, how can he paint those pictures? There's some mystery somewhere." The "mystery" was Renoir himself: a fascinating mystery which I shall not try to explain, but only comment upon, in this memoir. I could write ten, a hundred books on the subject of the Renoir mystery and I should be no nearer to solving it.

Since I have begun on Renoir's physical characteristics, I may as well give a few more details. Before he became paralyzed his height was about five feet ten. Now had he been able to stand upright, he might not have been as tall, for his spinal column had shortened slightly. His hair, which had once been light brown, had turned white, but was still quite thick at the back of his head. On top, however, he was completely bald, a feature which was not visible since he always wore a cap, even indoors. His nose was aquiline and gave him an air of authority. He had a beautiful white beard, and one of us always kept it trimmed to a point for him. Curiously enough, it curved slightly to the left, owing to the fact that he liked to sleep with the bedclothes tucked well up under his chin.

As a rule he dressed in a jacket with a buttoned-up collar and long, baggy trousers, both of striped gray cloth. His lavallière[1] cravat, royal blue with white polka dots, was carefully knotted round the collar of his flannel shirt. My mother used to buy his cravats in an English shop because French manufacturers had gradually let their blue turn to a slate color: "A sad color; and nobody has noticed it because people haven't got eyes. The shop assistant tells them it is blue, and they

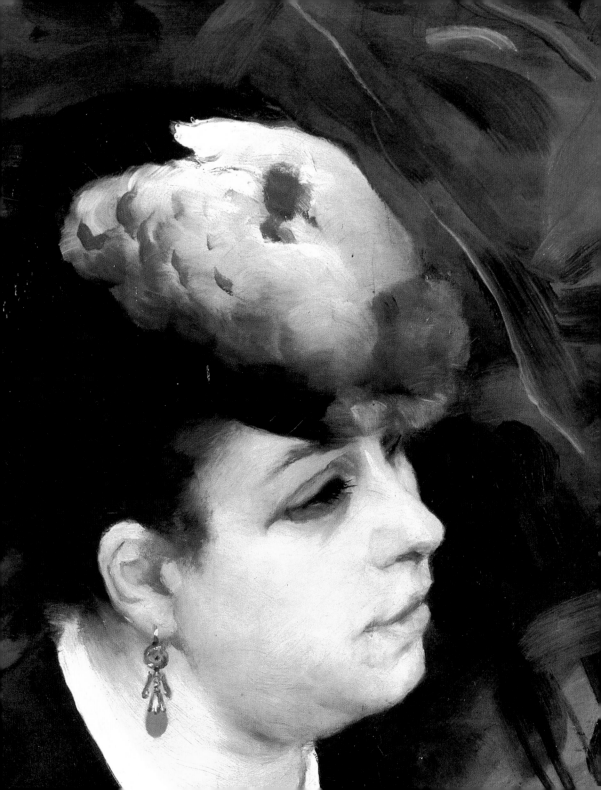

believe it!" In the evening, except in summer, a little cape was put around his shoulders. He wore high, gray-checked felt carpet slippers, or else plain dark brown ones with metal clasps. Out of doors he was shielded from the sun by a white linen hat. In the house he preferred a cloth cap with earflaps of a type advertised by novelty stores at the beginning of the century as "chauffeurs" caps. He did not look much like a man of our times, but made us think of some monk of the Italian Renaissance.

Cézanne once happened to complain to my father about a well-to-do man in Aix-en-Provence. It seems that the fellow was not only guilty of adorning his parlor with a picture of Besnard[2]—"that *pompier* who catches fire"[3]—but he took the liberty of standing next to Cézanne at Vespers and singing off key! Very much amused, Renoir reminded his friend that all Christians are brothers, and added: "Your 'brother' has a right to like Besnard, and to sing off key at Vespers too, if he chooses. After all, both of you will be in heaven together for eternity."

"No," retorted Cézanne, and continued, half seriously and half joking, "Up in heaven they know very well I am Cézanne." It was not that he thought himself superior to the man in Aix, he simply knew that he was different—"as a hare is different from a rabbit!" Then he said, contritely: "I don't even know how to work out my problem of volumes as I should … I'm nothing at all …"

This mixture of grandiose pride and no less grandiose humility was perfectly understandable in Cézanne. He had never been asked to exhibit in the Salon of "Monsieur Bouguereau."[4] Although Renoir had been criticized and vilified and often insulted in his day, he had, towards the end of his life, succeeded in establishing a wide reputation. The art dealers were all competing furiously for his work; the great museums everywhere had opened their doors to him; the younger generation in

every country had begun to make pilgrimages to Cagnes in the hope of being allowed to see the master for a few moments. He accepted all these tributes with a grain of salt. Whenever people would start singing his praises, Renoir would quickly bring them down to earth: "Who? Me? A genius? What rot! I don't take drugs, I've never had syphilis, and I'm not a pederast. Well, then …?"

[…] Renoir recognized that in the modern world work must be divided among specialists in each field, but he would not accept any such ruling for himself. If we have sore feet, we go to the chiropodist; if we have toothache, we see a dentist about it; if we get depressed, we pour out our troubles to the psychoanalyst. In the factories one workman tightens the bolts, while another adjusts the carburetors; out in the country one farmer grows apples, and nothing but apples, and another plants wheat. The result is magnificent; millions of carburetors; tons of wheat; apples the size of melons. The nourishment destroyed in fruit and vegetables by increasing their size is made up for by the use of appropriate vitamins. And all goes well. People eat more, go to the movies more, and get drunk more often. Life expectancy is longer; and women have the benefit of painless childbirth. The entire output of Renoir's work, so full of natural vitamins, is a cry of protest against this system, as his life was also.

The world of Renoir is a single entity. The red of the poppy determines the pose of the young woman with the umbrella. The blue of the sky harmonizes with the sheepskin the young shepherd wears. His pictures are demonstrations of an over-all unity. The backgrounds are as important as the foregrounds. It is not just flowers, faces, mountains, which are put in juxtaposition to each other: it is an ensemble of elements which go to make one central theme, and they are bound together by a feeling of love which unites the differences between them.

La Grenouillère (detail), 1868 St. Petersburg, The State Hermitage Museum

following pages *The Theatre Box* (detail), 1874 London, Courtauld Institute Gallery

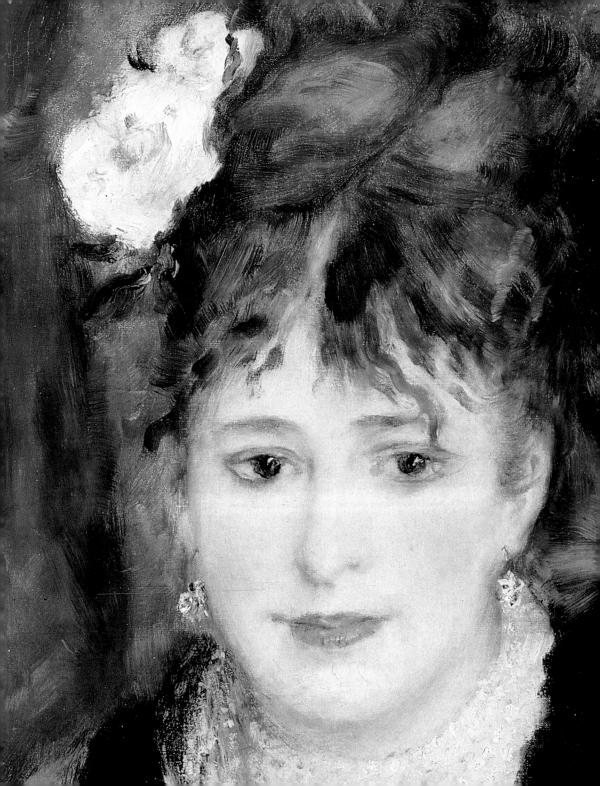

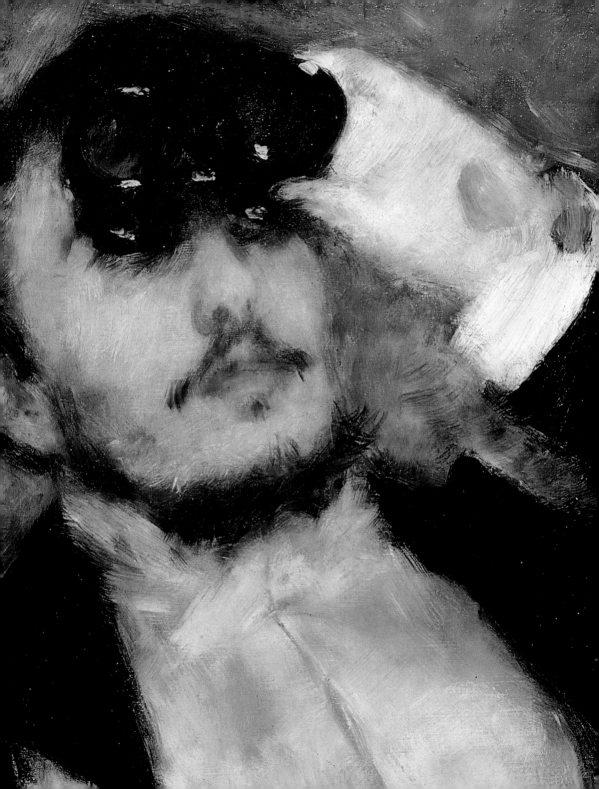

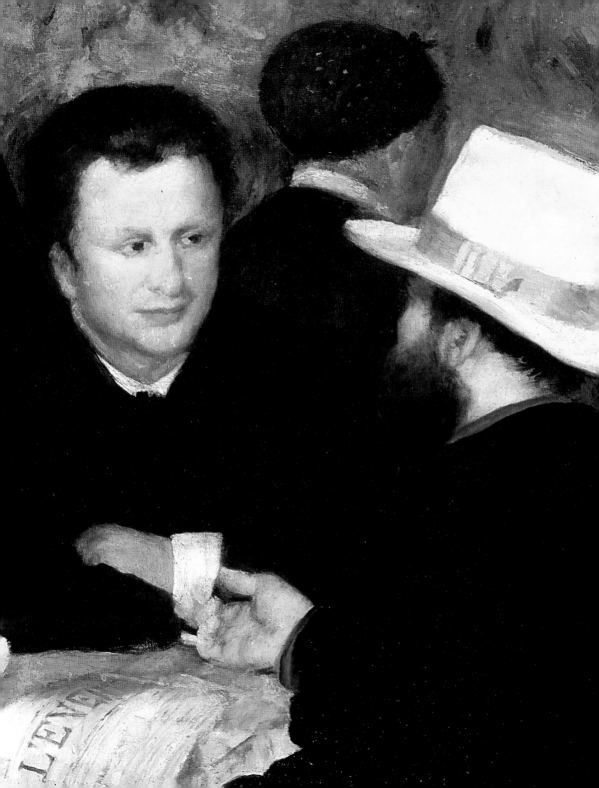

When one evokes Renoir, one always comes back to that vital point. In his world mind is liberated from matter, not by ignoring it but by penetrating it. The blossom of the linden tree and the bee sipping the honey from it follow the same rhythm as the blood circulating under the skin of the young girl sitting on the grass. This is also the current in which the symbolic "cork" is carried along. The world is one. The linden, the bees, the young girl, the light and Renoir are all part of the same thing, and of equal importance. And the same holds true of the seas, the cities, the eagle soaring above the mountains, the miner deep in the mine, Aline Charigot feeding her little son Pierre at her breast. In this compact whole each of our gestures, each of our thoughts, has its repercussions. A forest fire will bring on a flood. A tree transformed into paper, and then into words, can drive men to war, or awaken them to what is great and beautiful. Renoir believed in the Chinese legend that a mandarin can be killed at a distance by an unconsciously lethal gesture made in Paris.

I now come back to the question of his theories. These, together with his constant technical experiments, served him as a springboard. He would try to find a certain quality of red by experimenting with contrasts. Again, having temporarily rejected ivory black, he would indicate his shadows with cobalt blue. And this blue shadow would determine the composition of the whole picture, even the subject. He would select this or that spot in the countryside because the shadow was blue there; and it is the cobalt blue, and not the original inspiration of the work, that creates the message we get from the picture.

To help us to understand Renoir's creative process better, I must quote one of his cryptic remarks: "I am not God the Father. He created the world, and I am content to copy it." And to show that he did not mean copying in the literal sense of the word, he told us the classic story

of the ancient Greek painter Apelles. In a competition that took place on the Acropolis, a rival of the Athenian master had submitted a picture which seemed to surpass any of the other entries. The subject of the picture was grapes, which were so realistically depicted that the birds came and pecked at them. Then Apelles, with a knowing wink, as though to say "Now you're going to see something!" presented his masterpiece. "It is hidden behind this drapery." The judges wanted to lift the drapery, but they could not—for it was the subject of the picture!

The Seine at Argenteuil (detail), *c.* 1873 Paris, Musée d'Orsay

I only wish it were possible to give an idea of Renoir's laughter when he had finished the anecdote. The one that followed, about the shoemaker, he found less amusing. It concerned Apelles also, and ran somewhat like this:

While the exhibition was going on, the master hid behind his picture in order to overhear what was being said about it. A shoemaker remarked that there was something wrong with the sandal on one of the figures in the painting. Apelles came out of hiding, thanked the shoemaker and corrected the error. The next day the fellow found the leg too thin. "Cobbler," said Apelles, "stick to your last."

Renoir added, in passing, that the Greeks probably did not know any other painting than mural art and that of decorating statues; and that such stories were purely literary inventions. He said, furthermore, that if the day ever came when the painter succeeded in giving an illusion of a forest which included the smell of damp moss and the murmur of a brook, painting would be finished for good and all. For, instead of buying the picture, the art lover would go and walk in the woods.

My insistence on the importance of external circumstances in Renoir's painting applies to all great artists, including Picasso, Braque and Klee. It may seem to contradict what I had to say about Toulouse-Lautrec. But I maintain that the accident he had in his childhood

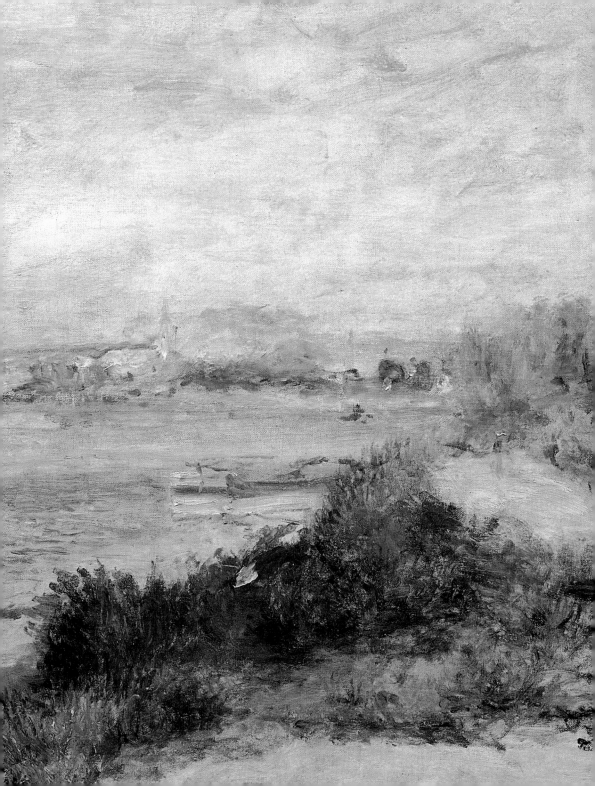

played only a secondary role in his life, and perhaps none at all, when it came to the question of expressing himself. He was first and foremost motivated by the unusual personality of his models. And to their personality he of course added his own, to a fantastic degree. Then he started out again from his observations, closing the circle and indirectly asserting that the world is not a bourgeois apartment house whose occupants pretend to ignore one another. Even if he had not had his accident, he would always have sought, and found, the type of models necessary to his art in the cafés of Toulouse or even in the Moulin Rouge in Paris, to which his destiny seemed to lead him more than did the need to forget his deformity. What I mean is that had he been deprived of the pathetic faces of the creatures he painted, he would have had a harder time finding himself.

More important than theories to my father was, in my opinion, his change from being a bachelor to being a married man. Always restless, unable to remain long in one place, jumping into a train with the vague notion of enjoying the misty light of Guernsey, or else immersing himself in the rose-colored atmosphere of Algeria, he had, since leaving the Rue des Gravilliers, lost the meaning of the word home. And here he was, installed in an apartment with his wife, taking his meals at regular hours, his bed carefully made every day, and his socks mended for him. To all these benefits another was soon to be added in the form of his first-born child. The birth of my brother Pierre was to cause a definite revolution in Renoir's life. The theories aired at the Nouvelle Athènes were now made to seem unimportant by the dimples in a baby's bottom. As he eagerly sketched his son, in order to remain true to himself he concentrated on rendering the velvety flesh of the child; and through this very submission, Renoir began to rebuild his inner world.

[1] Named after Mlle. de la Vallière, mistress of Louis XIV.

[2] (1849–1934). French painter who studied with Cabanel in Italy and won the Prix de Rome.

[3] A play on the French word *pompier,* which means not only "fireman" but anything banal or academic in art.

[4] Adolph William Bouguereau (1825–1905). French painter. Prix de Rome. Member of the French Institute. His most ambitious work is his large "Apollo and the Muses" in the foyer of the Opéra at Bordeaux. Highly popular in his day, he has been stigmatized as trivial and academic by many modern critics.

His Life and Art

"While theories, doctrines, aesthetics, metaphysics and systems of art came and went, Renoir's work developed year after year, month after month, day after day with the simplicity of a blossoming flower, a ripening fruit," wrote the critic Octave Mirbeau during an individual show for the painter in the Bernheim gallery in Paris. The critic went on to say that Renoir "lived and painted. He pursued his craft. This is perhaps wherein his genius lies. As such, his entire life and his work are lessons in happiness." It was 1913 and the elderly painter was watching a generation of his descendants grow up; the generation of Picasso, Matisse, Kandinsky, Malevich, and Mondrian, artists who certainly considered their art something quite other than a "craft," claiming a higher stature for it.

"Working as a good workman," "making good painting." These phrases recur often in the painter's letters and reveal his awareness of the importance of *doing*, faith in the sole expressive means of the paintbrushes and canvas.

The critic Carlo Ludovico Ragghianti observed that Renoir's artistic pursuit "has nothing intellectual about it" Throughout his long career, the painter kept himself completely separate from theoretical considerations, even when in the 1860s and 1870s he and his impressionist friends were involved in a critical battle against the dictates of academism and Salon art, official art, the art that received recognition by the bourgeoisie and upper classes.

Renoir's canvases are an expression—at times ingenuous—of the pleasure of life and natural beauty and, above all, the immense joy of painting. The master's extremely prolific output (his œuvre includes over 5,000 canvases and an equally impressive number of drawings and watercolors) was born of the boundless creative verve of a painter who did not even stop when later in his life a form of arthritis deformed his hands, causing him serious pain in his work.

There are but very few occasions in which Renoir picked up a pen to write in the place of

his paintbrush. One was in the introduction to the French edition (1911) of the *Libro dell'Arte* by Cennino Cennini, the Florentine painter who lived in the fourteenth and fifteenth centuries and wrote a treatise of indispensable practical concepts for beginning painters, such as how to mix colors, which brushes to use, the qualities of different supports, and passages on decorative art works of every genre. Renoir wrote in his introduction, "It may seem that we are quite far from Cennino Cennini and from painting. Yet, this is not the case, as painting is a craft like carpentry and ironworking and it is subject to the same rules." There is good reason that Renoir approached the world of art as an artisan, specifically as an apprentice in the workshop of porcelain painters, which is where he began working when he was thirteen.

Pierre-Auguste Renoir was born in Limoges on February 25, 1841, the fourth of five children, to Léonard Renoir, a tailor, and Marguerite Merlet, a seamstress. When Pierre-Auguste was three years old, his parents decided to move to the growing metropolis of Paris, which was undergoing major changes in its urban organization. The emperor Napoleon III had assigned an immense project of urban redesign to the prefect of Paris, the baron Georges-Eugène Haussmann, partly to modernize the city and its infrastructures and partly to better control the city's quarters after the violence of the revolutionary uprisings in March 1848. To make room for the large boulevards and enormous star-shaped squares, Haussmann's project destroyed much of the medieval neighborhoods in which the working class lived, forcing them to move to the city's outskirts. For these people, it was sudden and violent change from the picturesque Paris of Victor Hugo's novels to the Paris of Émile Zola, a writer who was friends with Manet and the impressionists and whose *Rougon-Macquart* cycle cast an unflinching eye on the social evils of the Second Empire. Renoir's family, which had emigrated like many others from outside of Paris in the hopes of improving

their conditions, also suffered the consequences of Haussmann's plan, being forced to move twice because of urban redesign.

Nonetheless, it seems that little Pierre-Auguste had a happy, carefree childhood, and demonstrated an early talent for drawing and singing (which he, however, never cultivated). When Charles Gounod, the children's singing teacher and chapel master at Saint-Sulpice, asked him to be part of the church's choir, even offering him free singing lessons, Renoir's father chose to encourage his son's talent for drawing instead, with the hope that he would become a porcelain painter, a traditional art in Limoges. In 1854, the youth entered the Lévi workshop in Rue du Temple as a porcelain painter apprentice, where he displayed his talent for floral decoration and then painting with more complex drawings such as a portrait of Marie Antoinette. It seems that at this time his highest aspiration was to get a job at the prestigious Sèvres factory. However, Lévi's business went bankrupt in 1958 after new industrial techniques were developed for decorating porcelain. Renoir was forced to work on his own, painting fans and decorating a café in Rue Dauphine, works of which nothing remains. His training in the decorative arts helped him develop an early acute sense for forms popular with the public, which always aided him in selling his work. The young Renoir found a job the next year with Gilbert, a painter specializing in sacred images. Here again, the versatility of Renoir's talent set him up to be widely appreciated.

Since these early days, Renoir was never satisfied with easy success and never stopped studying. In 1854 he started an evening course at the École de Dessin et d'Arts Décoratifs (directed by the sculptor Callouette), where he formed a friendship with the painter Émile Laporte, who encouraged him to dedicate more time to painting. In 1860, the young man received permission to study the old masters at the Louvre, taking particular interest in Rubens, Fragonard, and Boucher. He admired Rubens's painting mastery in the rendering of soft and sensual flesh. The paint-

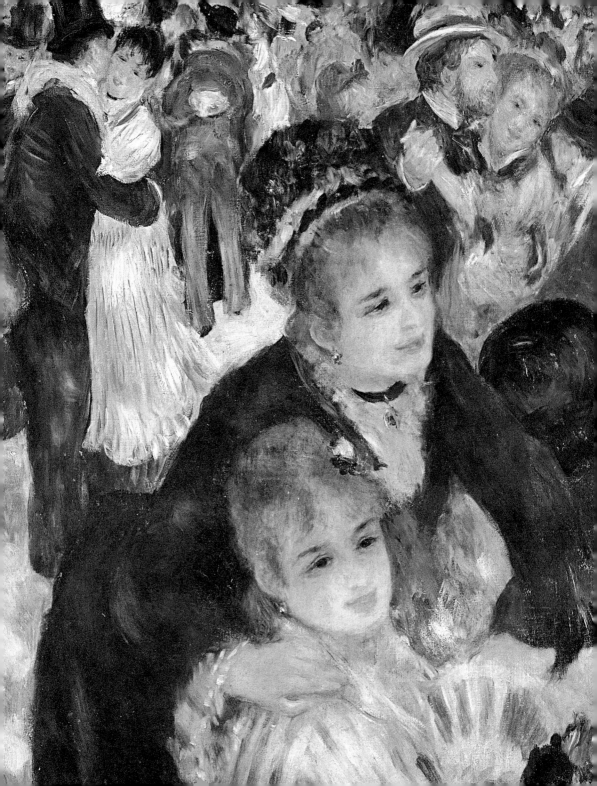

ings of the eighteenth-century masters fasci-
nated him with their delicate tonal passages
and the immersion of human bodies in the
surrounding nature. Renoir made these enthu-
siastic visits during his breaks from work.
They gave him a lesson with which he was to
engage throughout his life. Indeed, in many
ways, Renoir is like an eighteenth-century
artist—from the time of Boucher and
Fragonard—reborn in the time of the bour-
geois, who expresses how the French tradi-
tion was exquisitely refined. On the other
hand we must not forget that he went head-
long into the twentieth century and its art,
despite his old age and his strength gone, he
flourished again, the sign of a spirit that was
as vigorous as ever.

In 1862 Renoir was admitted to the École
des Beaux-Arts, where he signed up for the
painter Charles Gleyre's courses. Here he
learned to perfect the technical aspects of his
art, practicing in studies of the nude, drawing,
perspective, and in all of the usual disciplines
in academic studies. He regularly passed his

exams without, however, excelling in the eyes
of his teacher, Gleyre, who warned him of
the dangers of "painting for fun." Renoir's
response was: "If I didn't have fun, I wouldn't
paint." His response and Gleyre's comment
represent two opposing concepts of art, seen
by the teacher as a grave formal exercise and
by the student as pleasure, as fun. Renoir
loves light and mixture, completely irregular
brushstrokes that work together to give the
impression of a luminous carpet in which the
colors meld with a flowing rhythm without
excess. His paintings, from his first attempts
in the Gleyre atelier to his last works in
Cagnes, share a joyful, reassuring effect. It is
obvious that the painter wants to give those
looking at his work a pleasure commensurate
with what he felt painting them.

In Gleyre's class he came into contact
with Alfred Sisley, Frédéric Bazille, and
Claude Monet, which was crucial for Renoir's
development as a painter. Like him, these
painters felt suffocated in the claustrophobic
environment of workshops and the sterility of

academic drawing. Following the example of the painters of Barbizon—a group of masters (Théodore Rousseau, Charles-François Daubigny, and Jules Dupré) who founded an artist's colony in 1848 in the forest of Fontainebleau for working exclusively outdoors—the young students of Gleyre's academy took a short trip in 1863 to Chailly-en-Bière, not far from Barbizon, to immerse themselves in wild nature like their predecessors, to practice painting *en plein air*.

In the spring of 1865 this experience was repeated when Renoir spent some time in the village of Marlotte, lodging with Sisley, Monet, and Camille Pissarro at the inn of Mère Anthony. In one of his first large works (1866) Renoir portrayed the simple, cozy environment of the Mère Anthony country restaurant. His friends Sisley and the painter Jules Le Cœur are gathered around a table. There is a dog in the foreground who looks at the observer while the inn's owner is about to clear the table. In this painting, like others from the same period (such as the portrait of

the Sisley husband and wife and *Clown* from 1868), the black of the clothes and the ochre of the floor dominate the color range. These are nods to Velázquez and seventeenth-century Spanish painting, which he knew through Manet, who in that period was discovering them in his own pursuits.

Beyond their admiration for the Barbizon school and for Manet, Renoir and his friend also shared an admiration for the confrontational charisma of the older Gustave Courbet, the father of realism who gave a historic dimension to the hardships of the poor. Also in Marlotte, Renoir had met Courbet in 1865 and the works of this master from Ornans showed him a previously unknown freedom in the use of painting subjects. Courbet's canvases are not just thin painted surfaces, windows that open onto a perspective illusion of a landscape or a historic figure. Courbet created a kind of relief in his works. Instead of a window on the world, his canvases became piece of raw material in which the depths of browns, grays, and blacks were molded sometimes by the paintbrush or sometimes with the point of the brush or with a palette knife. Although Renoir was not interested in the social themes important to Courbet, the influence of this painter from Ornans, particularly his great freedom in the use of subject matter, was a fundamental experience for Renoir's painting and the birth of impressionism. *At the Inn of Mother Anthony*, together with the portrait *Alfred Sisley and His Wife* and *Diana the Huntress* are important documents of realism from the 1860s, continuing later with *Bather with a Griffon*, which, though painted when the artist was twenty-nine years old and had turned his pursuits toward other directions, still clearly shows the influence of Courbet's rough and raw vision.

Renoir was admitted to the Salon in May 1865 with two works, including the portrait of Alfred's father, William Sisley. The year before his *Landscape with Two Figures* was rejected, despite the support of two members of the committee, Corot and Daubigny.

During this period, being in serious economic straits, the painter shared a house with Alfred Sisley. When he married, Renoir moved into Bazille's studio on Rue Visconi where Monet would later live. For the Salon of 1867, Renoir painted a female nude that he titled *Diana the Huntress* (1867). He was well aware of the scandal that Manet had caused four years earlier in his *Déjeuner sur l'Herbe* (1863), which he had shown at the Salon des Refusés (for artists not admitted to the official Salon) a female nude surrounded by men in modern clothes, without veiling it behind some mytho-logical facade, launching the challenge of contemporary culture with a raw and real-istic language. To avoid accusations of obscenity and the resulting rejection of the selection jury, Renoir placed a dead deer in the foreground to allegorize the figure. This turned his model Lise Tréhot into Diana, the goddess of hunting. As the painter recollected: "I did not intend to do anything other than a nude study. But the painting was considered indecent, so I put a bow in the model's hands and a deer at her feet. I added an animal skin to make her nudity less shocking and the painting became a Diana!" Unfortunately, his efforts went to waste and the work was rejected by the jury who criticized it for its crude subject matter.

Lise's features can be recognized in many of the masterpieces from Renoir's early period, such as the Manetesque *Lise with Umbrella* (1867), exhibited at the Salon of 1868 and admired by the critic Zacharie Astruc; *Gypsy Girl* (1869), shown at the 1870 Salon; *An Algerian Woman* (1870); and the *Parisiennes in Algerian Costume* (1871–1872). The girl, whom he met in Marlotte at the home of his friend, the painter Jules Le Cœur, was his favorite model for several years. She and other models, such as Alphonsine Fournaise and Gabrielle Renard (who was governess to his children), played an important role in the genesis of Renoir's masterpieces (this has been duly noted by critics, who have suggested a parallel with Picasso).

The silent dialogue between painter and

model is an experience of great intimacy. It is not only the model who reveals herself to the painter. The painter, in sharing the crucial moment of a work of art's genesis with another, must bare himself, too. It seems that Renoir was not able to paint objects and people who were not in some way part of his life. Many of the people he portrayed, especially in his later works, were family members and friends. The familiarity, the relationship of trust he has with his model cannot be replaced by an anonymous model paid for part-time work, as was customary in the academy.

In order to take a step forward in changing painting, Renoir and his friends (who would form the group of impressionists) had to free themselves from literary subjects, whose burden prevented an unprejudiced relationship with modernity, which was essential to them. A realist painter like Courbet successfully transfers a piece of material to the canvas, making his subject what had always been considered ugly and improper; still his works came out of profound consid-erations and are rich in meaning. The first impressionist canvases were, in contrast, primarily formal exercises, painted impressions made outdoors in front of the subject.

Renoir and his friends understood that to make true painting history in those years, they needed to represent the life of their own era, instead of looking back to past centuries. This is why the painters left the arid atmosphere of their studios to work *en plein air*, adopting new habits for painting outdoors, surrounded by nature, in the environment that they were painting. Artists had sketched their paintings outdoors at least since the seventeenth century, but the steadfast rule was to complete them in the studio, in carefully planned and controlled conditions. The impressionists encouraged the myth that their works were completed on the spot in a single session. It must be said that in reality, though they masterfully managed to simulate this effect, it was rarely true of works intended for sale.

Café Guerbois, in Rue des Batignolles, was the gathering point in these years for Renoir and

his revolutionary friends Bazille, Monet, Sisley, and Pissarro. Here the eldest painter Édouard Manet was the center of a group of admirers (including Émile Zola) and art lovers. Conversations revolved around *en plein air* painting experimented with by the artists and new techniques of color rendering of light. Still, Renoir did not scorn participating in official exhibitions and in May 1869 he was accepted to the Salon with *Gypsy Woman*. In the academic environment, he met Henri Fantin-Latour, whose painting *Un Atelier aux Batignolles* (1870) portrays Renoir and his friends, significant in the centrality given to Manet amongst the group of young men.

An homage to Manet and his artistic pursuits was also found in Renoir's *Still Life with Bouquet* (1871), which portrays a bouquet of flowers in the foreground next to an Oriental vase and a fan. A print can be seen in the background of the work titled *Les Petits Cavaliers*, an etched translation of a copy Manet had painted in the Louvre from a presumed Velázquez original. The print, along with the Oriental objects, clearly references the famous *Portrait of Émile Zola* (1868), a work by Manet, which shows a print by Velázquez in the background alongside a Japanese woodblock print and a nod to his *Olympia* (1863). It is clear that Renoir wishes to reconnect himself here to Manet and his models, which is backed up by the unusual "statement of poetics" that he had made in his portrait of Zola.

The painter's relationship with Claude Monet intensified in the summer of 1869. He made frequent visits to Monet's home in Saint-Michel. They worked together on the island of Croissy, on the Seine, painting the same subject, a floating *cabaret* in the Grenouillère area, with restaurants frequented by crowds of Parisians on Sundays. This is where the first steps were taken toward the painting style that would later be called impressionism. The two painted side by side, with short and vibrant brushstrokes, studying the crowd walking by, bathers, the lights of warm

summer afternoons as they reflected on the water, from nearly the same perspective.

The "modernity," so to speak, of Renoir's painting and impressionist painting in its complex full expression is in freeing itself from the subject, from the literary content that traditionally cloaked the work. From this point on, the subject would be treated with the special combination of tones and colors that made an "impression" on the artist. The artist sets about to reproduce the impression on the canvas, with an almost childlike gaze, stripped of all of the cultural baggage of one's academic notions and personal visual heritage before that moment, to that impression, to express it to the viewer of the painting in all of its purest authenticity.

Renoir would later abandon this spontaneity without form for a more traditional style based on the discipline of drawing. In this period, he was still connected to his friends Monet, Pissarro, Sisley, and others in painting authentically "modern" works, based on modern life in which the subject is merely

an opportunity to capture the fluctuating effects of natural light.

This carefree period of painting experimentation and outdoor living was abruptly brought to a halt in 1870 when the Franco-Prussian war broke out. Renoir was drafted and enlisted in July in a regiment of *cuirassier* and sent to Bordeaux, then to Vic-en-Bigorre, near Tarbes in the Pyrenees, (where he worked training horses, despite having no experience). His friend Bazille enrolled as a volunteer in August and died on November 18 in the battle of Beaune-la-Rolande. Renoir returned to Paris after the surrender of Sedan during the chaotic period of the Commune. He had a passport during this period that authorized "citizen Renoir" to do his work in public.

The war, the defeat and the demise of the Second Empire, did little to help artists on the road to success. Renoir led a precarious bohemian life for many years. In 1877 he confided in Théodore Duret, a historian of the impressionist movement, that he was in a situation from which he had trouble seeing his

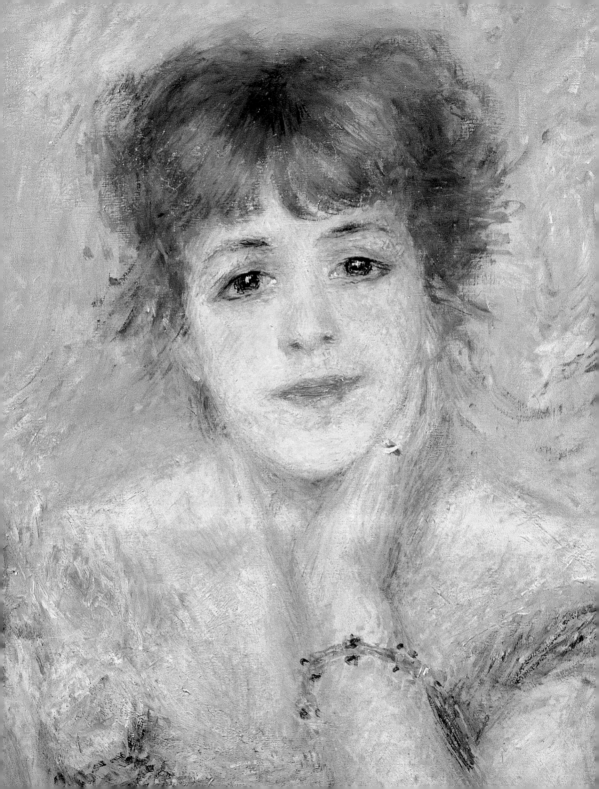

way out. Renoir and his friends had been marked as "impressionists" during the 1870s, and had to contend with the open hostility of French critics.

The meeting at the Café de la Nouvelle Athènes in Place Pigalle (which had replaced Café Guerbois) gave the artists an opportunity for discussion and heated debates in which there was disagreements on many points, as well as the chance to get together and share common experiences. On these occasions, Renoir was mainly described as quiet and intent on doodling charcoal drawings on the table—an image perfectly in keeping with the painter's anti-intellectual character—unable to understand such things as why Zola was so passionately against the nymphs in Corot's forest scenes and wanted to put peasants in their place. The only thing that mattered to him was that they were painted well!

In 1874, Renoir worked once again alongside Monet on the banks of the Seine, this time in Argenteuil. The two painted together (sometimes joined by Édouard Manet, who had found a home for them), using rapid, light brushstrokes for landscapes (see *The Seine at Argenteuil*) and figures immersed in sunlight reflected in the Seine. It has been written that impressionism came out of studying and trying to render the reflections of figures and vegetation in water. Monet had a boat in those years that served as a full-fledged floating studio. It was large enough to sleep on, and he loved watching from it the effects of light on the water at dawn and dusk. Indeed no place is so much identified with impressionism as Argenteuil, where all, or almost all, of the friends worked. It was in Argenteuil, watching Monet paint, that Manet was converted once and for all to *en plein air* painting, preferring to study figures outdoors rather than follow Monet's attempt to render the pure landscape. He would pose his friend's wife and son under a tree, achieving the unity between figures and environment typical of portraits in those years. When

37

Renoir arrived and found Manet at work, he could not resist the charm of the scene and asked Monet for a palette, canvas, and paints to capture the same scene alongside Manet. In a single session he painted *Madame Monet and Son in the Garden at Argenteuil*. For Renoir there were now no points of less importance in the context of a painting. Fluid brushstrokes and strikes of the palette knife followed one another, seemingly randomly, to then come together in a coherent, highly luminous view.

The name of the two friends, Monet and Renoir, were often paired during this period because of their habit of working together. It should be clarified, however, that their painting had specific, distinctive traits. Monet's painting was careful and meticulous; Renoir's was hazy and flowing. Their enduring friendship—dating back to their studies at Gleyre's atelier and *en plein air* sessions in front of their subjects—is evidenced by the portrait of his friend that Renoir painted only two years before.

The group's first exhibition took place in that same year, opening on April 15, 1874 in the photographer Félix Nadar's studio at 35 Boulevard des Capucines. The exhibit of a total of 163 works included drawings, watercolors, and pastels. It was preceded by the founding of a joint stock company, a cooperative of artists, painters, sculptors, engravers, and so forth, joined by Renoir, Monet, Pissarro, Sisley, and Degas, as well as by Armand Guillaumin, the painter Berthe Morisot and the engraver Félix Bracquemond. Manet's name was not on the list as he chose not to exhibit with them, while others, such as Cézanne, joined and painters were involved —such as Giuseppe De Nittis—who had already successfully exhibited at the Salon. Edgar Degas wrote that, thanks to the participation of these painters, "the misinformed cannot say we are an exhibit of those who were rejected." Their fear was to be thought of as mediocre painters who could not measure up to the masters of the Salon. The group's projects, it is evident, were intended

Boats on the Seine,
c. 1869
Paris, Musée d'Orsay

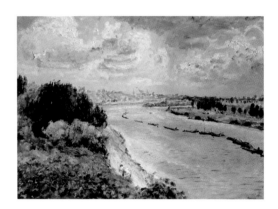

as a statement of independence from the Salon's aesthetic canons.

A look at the list of participants shows that there was a heterogeneous group of artistic personalities in Nadar's studio, sharing, quite broadly, technical interests and prefer-ence for modern subjects and disdain for certain mechanisms in the Second Empire's artistic culture. Renoir was in charge of curating the show and had great difficulty in trying to create a unified show with such diverse works. Finally, as De Nittis had left for England, he decided to leave out a painting by the Italian painter. Degas inter-vened, once he realized what had happened, so that the work was returned to the exhibit (though with a few days' delay).

Renoir's difficulty is easy to understand. Beyond the De Nittis situation, there could hardly be a more glaring lack of cohesion between the works of the members of the "company." We need only compare the works of Monet and Degas. Monet is basically a landscape painter, interested in rendering the

effects of light with decisive and concise brushstrokes. Degas was a follower of Ingres' linear style, and was focused on painting interiors portrayed with compositional styles that were reminiscent of the era's photography.

It should be kept in mind that the term "impressionism" was coined by hostile critics who intended to deride their works. There were many, quite different artistic pursuits in the group, which means it does not make sense to talk about an impressionist "style" in the sense of a specific uniform "manner of painting." Any adjective that contained these painters in one school would be limiting for each of them and would not serve to fully express their work's complexity. Indeed, the interest of these painters is in their total lack of a single style. If there is something that links the works shown at Boulevard des Capucines, it is the spontaneity and freshness with which the artists addressed contemporary life.

The most scathing (and certainly most witty) expression of critical hostility was found in the article "L'exposition des Impressionnistes" in the satirical magazine *Le Charivari* on April 25, 1874. The author, Louis Leroy, pretended to have visited the exhibit with Joseph Vincent, a landscape painter who was popular in the academic milieu. Leroy passed on comments to the readers that the painter was to have made looking at some of the works on display. About Monet's *Impression, Sunrise* (1872), a view of the morning sun at the port of Le Havre in which the painter represents the hazy, vibrant atmosphere with a few quick brushstrokes, Vincent sarcastically commented: "What freedom! What ease of workmanship! Wallpaper in its most embryonic state is even more finished than that seascape." Criticism of Renoir's works in the exhibit were of a similar tone, though possibly less withering. He had six canvases and a pastel, including *The Bench* (1874), *The Harvesters* (1873), and the *Dancer* (1874). Vincent commented about the *Dancer*, "What a pity that the painter, who has a certain understanding of color,

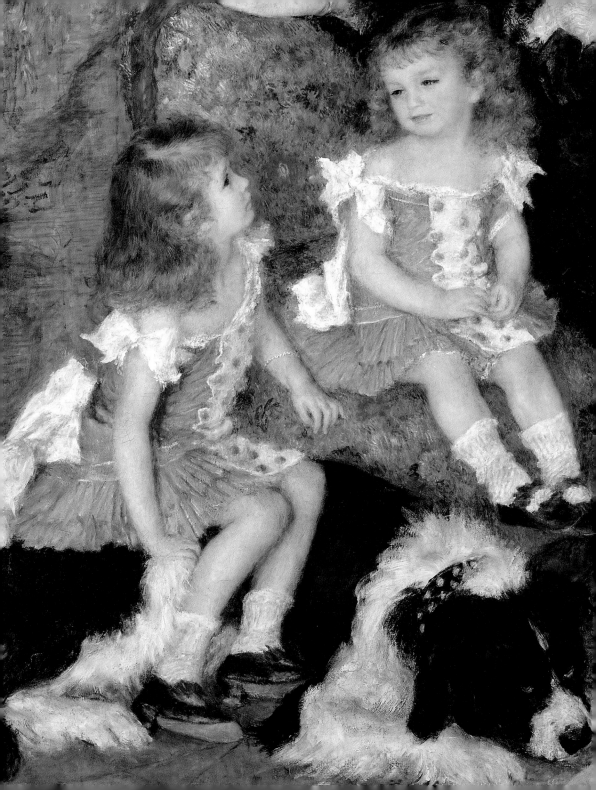

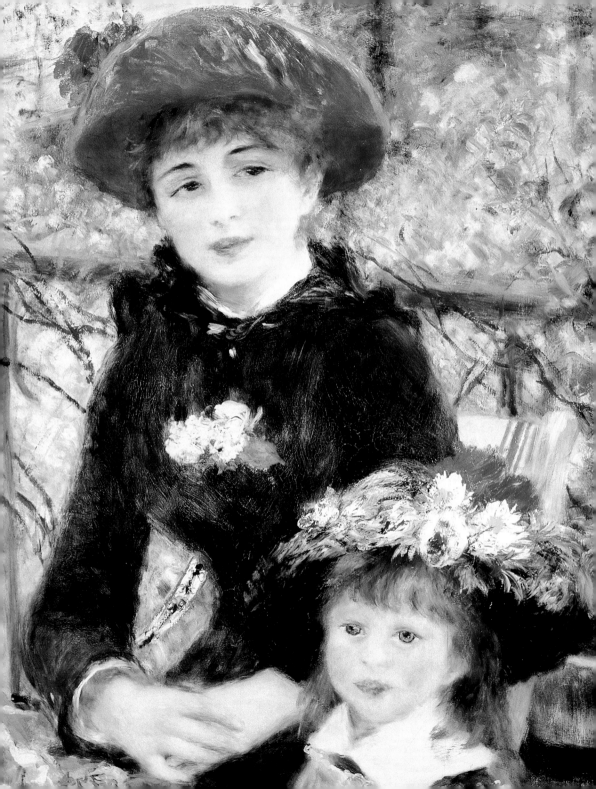

doesn't draw better; his dancer's legs are as cottony as the gauze of her skirts."

Leroy's article played a lot on the term "impression" because it implies that sense of vagueness and insubstantiality that, according to conservative critics like Vincent, defined the formal aspect of the exhibited works. "The impression that the Impressionists give is of a cat walking on piano keys or a monkey that has taken over a box of paints," wrote the much-feared critic Albert Wolff in *Le Figaro* in 1875. In the Parisian milieu of the time, the saying spread that the method of these painters involved loading a pistol with different tubes of paint and shooting at the canvas and then signing the result.

In Émile Zola's novel *L'Œuvre* (1886), he summed up the apparently disastrous reaction to the show: "The laugh that you heard was no longer a laugh muffled by the handkerchiefs of ladies. Men's stomachs expanded with laughter as they let their mirth loose. It was the contagious laughter of a crowd who came to amuse themselves, who got more and more worked up, and started bursting into laughter over nothing, pushed to mirth as much by the beautiful things as the execrable ones."

Nonetheless, part of the criticism tended to admire the initiative of the young men, especially their pursuit of independence. Yet these were but reviewers who, like Jules-Antoine Castagnary, managed to recognize the talent and freshness in their paintings. He wrote, "There is talent here. In fact, there is a great deal of talent. These young people have a way of understanding nature that is neither boring nor banal. It is alive, sharp and light; it is a delight. Such instant understanding of the object and such fun brushstrokes! It's true that it is brief, but the allusions are so right!" Castagnary seemed to be responding to the criticism in Leroy's article in writing, "If one wishes to characterize and explain them with a single word, then one would have to coin the word *Impressionists*. They are impressionists in that they do not render a landscape, but the sensation produced by the landscape."

In 1875, the year after the exhibition at Nadar's, Renoir persuaded the impressionist painters Berthe Morisot and Monet to organize a public auction at Hôtel Drouot, hoping to solve the serious financial difficulties with which they all struggled, but their paintings took rather modest prices. The sale—at which the dealer Paul Durand-Ruel, who was close to impressionist group, acted officially as the expert—was a scene of unprecedented violence. The public shouted at every bid and the auctioneer had to call the police to stop altercations from degenerating into a brawl.

Nonetheless, a circle of admirers and art dealers was gradually forming around the painter. During the Drouot sale, Renoir met Victor Chocquet, a customs official who was a great fan of Delacroix and became an important collector of impressionist painters (his favorites would become Renoir and Cézanne, of whom he came to own eleven and thirty-one paintings, respectively). He immediately commissioned Renoir to paint a portrait of his wife and himself. The painter portrayed Madame Chocquet in her apartment in Rue de Rivoli against a wall in a room in which a painting by Delacroix hung, following the collector's express instructions, pairing two artists he loved with an eye remarkably free of the prejudices of the time: "I want to have you two together, you and Delacroix."

Renoir started dedicating more time to portrait painting for commissions (in addition to the portrait of the Chocquets, there were those of Madame Charpentier with her children, of Jeanne Samary, and Madame Daudet). A stranger to the fierce idealism of painters like Monet or Cézanne, he was willing to compromise and paint what the clients wanted to see. The art dealer Ambroise Vollard remembered an anecdote that Renoir himself told him on that subject: "Even when I managed to get the commission out of them, how much effort it took to then get the money! I remember the case of a portrait of the wife of a shoemaker that I painted for a pair of shoes. Every time I thought I had

Au café, c. 1877
Otterlo, Kröller-Müller Museum

finished and already fancied myself the happy owner of a pair of boots, along would come an aunt, a daughter, a maid. 'You don't think that my granddaughter, my mother, my land-lady has such a long nose?' I wanted the shoes so I gave the fine lady a nose like Madame Pompadour's."

At the second and third show of the impressionist group, held in the years 1876 and 1877, Renoir exhibited some important paintings that would remain at the peak of his art. To this day they are the best-known icons of his art. *Nude in the Sun*, shown at the second impressionist show in 1876 at Durand-Ruel, drew the immediate censure of Albert Wolff in *Le Figaro*. He was unim-pressed by the painter's color explorations: "Try to explain to M. Renoir that the torso of a woman is not a mass of decomposing flesh, with green and purple patches like a corpse in a state of utter putrefaction! This is the jumble of coarse things that is shown to the public with no regard to the dire consequences that may come of it! Yesterday

45

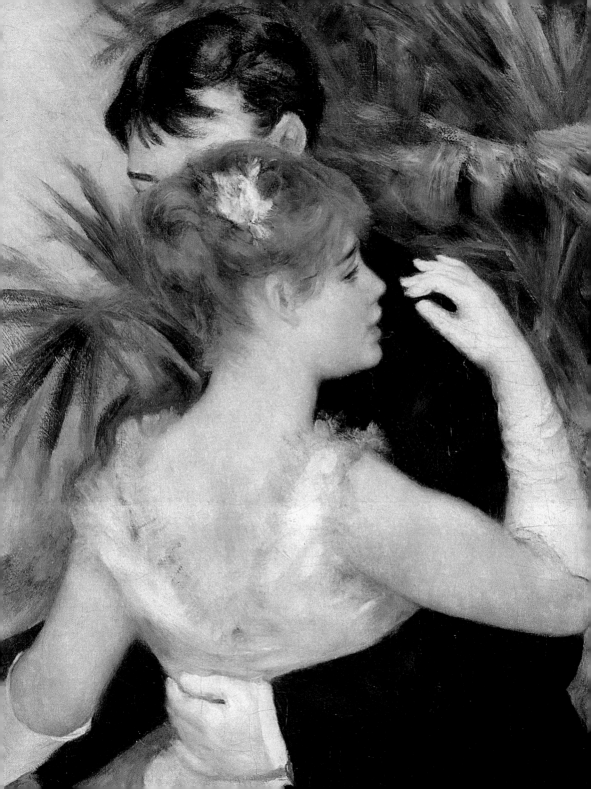

in Rue Peletier they arrested a poor man who bit passerbys as he left the show… these misguided people are to be pitied." This painting, like *The Swing*, came out of *en plein air* seasons in the attempt to achieve a more immediate and fleeting rendering of the light of the sun reflecting on the woman's skin, clothes, and the stylish hats of two men on the ground in the shade of the trees. While Renoir continued to mix colors on his palette, from here on out, he began juxtaposing little pockets of pure color on the canvas that combine in the observer's eyes following precise optical rules, while maintaining their specific quality of luminous vibration. This new method made the painter a master at representing sunlight in the outdoor world, expressing a kind of dizzying immersion in nature. An excellent example of this is seen in *Le Moulin de la Galette*, which was shown at the third impressionist show in 1877. Renoir moved to paint it near the gathering spot in Montmartre for six months, where he came into contact with that little world that has its own look that still models could not repeat, set amidst the whirlwind of a casual party, rendering lights, colors, movement and atmosphere that surround it with bewildering vivacity. He painted a first version outdoors (now part of the Whitney Collection in New York), based on a more direct, immediate gaze. Later in the studio he painted the version (now at the Musée d'Orsay) which could be called final, though nothing appears truly finished in this painting whose subject gives the illusion of trembling with life.

The impressionist exhibition in 1877, the third of the shows, would be the last time the old friends—Cézanne, Degas, Renoir, Monet, Morisot, Pissarro, and Sisley—would be together again. From this point on, the group gradually drifted apart. Renoir was becoming increasingly recognized at the Salon at this time. He would only exhibit with the others once more in 1882. But by that time he would already be far from the movement, having abandoned working outdoors. A trip to Italy

the year before that opened up a new horizon in his development as a painter.

Yet, it was Renoir who was the first member of the group to have accepted the "impressionist" definition, despite it being applied by hostile critics. In 1877 he convinced the art critic Georges Rivière to publish a weekly magazine called *L'Impressionniste* to give space for reviews and articles about modern art. This endeavor was not fated to be long lasting. Only four issues were published between April 6 and 28, 1877. Regardless, it was in *L'Impressioniste* that Renoir responded to those among the public who treated their exhibitions with open hostility. In *L'art décoratif et contemporain* (1877), Renoir criticizes the eclectic nature of contemporary art which tries to mask the signs of modernity with excessive decoration. One such example was the monumental Opéra Garnier theater (1861–1875), whose advanced industrial construction technologies are clad in abundant sculptural decorations that seem to be a great *potpourri* of Renaissance and Baroque elements. Renoir commented, in open opposition to fans of the Opéra Garnier, "Les Halles [an enormous industrial architecture complex that held the public markets] are the only buildings that have a truly original character and a structure fitting their use. Yet there is not a single modern building that compares to Notre-Dame, Hôtel de Cluny or the old Louvre. Our buildings are caricatures, more or less clumsy, of those beautiful works." Renoir went on to say that for the painted decorations within the Opéra "the painters thought of Venetians and of Germans, of Delacroix or Ingres, yet none of them knew how to be decorators." Renoir was fiercely critical of official art (architecture and decorations from the Second Empire and after), accusing it of being self-involved, studying and reinterpreted styles of the past with technical skill and profound erudition while lacking an innate decorative sensibility. The only exception he made was Eugène Delacroix, whose mural paintings for the church of Saint-

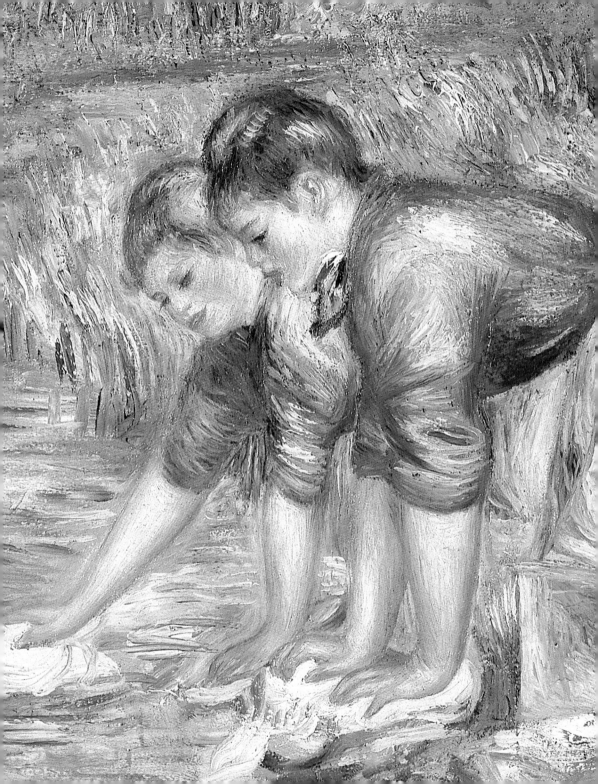

Sulpice (1853–1861) were a "mere pretext for making art." According to Renoir, the artist had managed to free himself from the conceptual burden of the theme to be illustrated and succeeded in simply offering a pleasure for the eyes of the viewer. Renoir said, "a painting is all the more decorative when its tones are varied in harmony." His own paintings sought to be primarily decorative.

It should be remembered that in the early 1870s, Renoir went through a phase of even more open experimentation, frequently paying homage to Manet and Courbet, as well as Delacroix, whose Orientalist paintings such as *Algerian Women* (1834) was a source of inspiration for his *Parisiennes in Algerian Custome* (1871–1872), and the earlier *An Algerian Woman* (1870). In the latter painting, Renoir portrayed Lise in Oriental costumes, turned with a clearly seductive gaze to the viewer. Renoir's intention, beyond presenting a formal type, was to recreate an atmosphere thick with sensual allusions—the fruit, the colorful fabric, and the veiled body of the woman—taken from Delacroix's models.

Given that Renoir persistently refused to think of himself as a revolutionary, and in fact often looked to the great French tradition (he never stopped believing in the museum as the perfect place to educate an artist), it has been sometimes doubted if he can really be counted as an impressionist. The question seems quite idle if we consider the artists at the first exhibition at Nadar's. Without exception, all of the painters had personalities of a complexity that can certainly not be limited in terms of a school or an "impressionist group." Renoir's artistic pursuit is defined by wonderful spontaneity. It differs from his impressionist friends because of the strength of the temperament underlying it, not inclined to forms of intellectualism, aimed at painting the sensory appearance of things without artifice. Meanwhile, Renoir found, in addition to Chocquet, solid moral and financial support in Paul Durand-Ruel, an art dealer who coura-

geously and with a fine-tuned instinct focused on the impressionists, from whom he had long been buying paintings without managing to place even one. He was also supported by Gustave Caillebotte, a wealthy engineer and painter who collected his friends' paintings with passion and acumen, though they were considered unsaleable at the time. In 1875, the editor Charpentier joined the circle of art dealers and friends. He introduced Renoir to the intellectual world in Paris. Renoir had never before gone outside of the circle of his painter friends. In Madame Charpentier's famous salon, where Zola, Edmond de Goncourt, Flaubert, Daudet, Maupassant and Turgenev felt at home, he painted the family in *Madame Charpentier with her Children.* This painting (for which he was paid the hefty sum of a thousand francs, the highest payment received for a painting in those years) is on the one hand a concession to the official genre of portraits that were in fashion at the time. Yet it is also clearly a turning point in Renoir's artistic development. Here he used a thick

Children's Afternoon at Wargemont
(detail), 1884
Berlin, Staatliche Museen
zu Berlin, Preussischer
Kulturbesitz, Nationalgalerie

paste for the first time, a quite measured, controlled language, very different from impressionist poetics. With this group portrait and the *Portrait of Jeanne Samary*, Renoir finally found himself in 1879 welcomed in the Salon, as he had hoped. He deserted the fourth impressionist show, accused by his old friends of having gone over to official painting and seeking worldly success. Given the quite scarce progress he and the others had made at the impressionist group shows, he justified his choice in a letter to the art dealer Durand-Ruel: "In Paris, there might be some fifteen connoisseurs able to appreciate a painter outside of the Salon. There are 80,000 people who do not buy a thing if the painter is not at the Salon. I do not want to waste my time fighting against the Salon. I do not want to even seem like it. I think that we should just make the best painting possible and that's all."

Beyond such issues of material opportunities—completely understandable for Renoir who came from rather humble origins and was used to having to work for his living, unlike painters like Cézanne and Manet—Renoir was going through a full-blown crisis, having brought his artistic achievements in question. He was not unaffected by criticisms made by Émile Zola (among the first to support the new art) in *Voltaire* in 1880 about impressionist painting, accusing it of being incomplete, extreme, and unable to master a style and a form.

Julius Meier-Graefe termed the stage in Renoir's career from 1881 to the end of the century the "party is over" stage. His peers also seemed disappointed by the changes in direction of an impressionist with such great skill in color. Renoir's "truly impressionist" paintings are in fact quite few. They date from the years 1874–1877, which were so full of controversies and critical battles for his friends and unforgettable *plein air* masterpieces for Renoir. The years after that period saw his aspirations take the form of moving more toward drawing than painting. The years before that saw his art still developing, oscillating between admiration for/and emulation

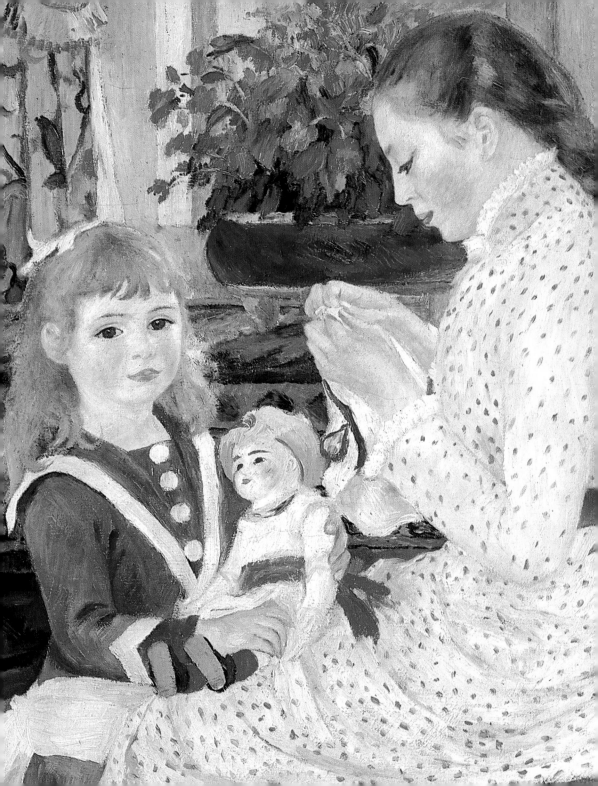

of Courbet and making modern takes on great French eighteenth-century masters in his heartfelt, tangible homage to Delacroix.

This radical shift was doubtlessly caused by new stimuli and cultural influences on trips the artist took starting in 1879. Renoir was thirty-eight; the pressure of his financial problems had been eased by the many orders for society portraits. He had spent his entire life in Paris and the Seine valley. Understandably, he wanted to see a bit of the world before his health, which was already unstable, declined.

In March of 1880, he went to Algeria, seeking the exoticism that had had such an appeal for Delacroix and that he felt firsthand and in his work. Upon his return to France he wrote Duret from Chatou that he had just been invited to take a trip across the English Channel, but that he had no need to go to England because where he was he was "grappling with flowering trees, with women and with children and I do not wish to see anything else." The reason behind this extended stay was the young woman portrayed with other friends in the large painting *Le déjeuner des canotiers*, Aline Charigot. As Renoir neared forty years of age, he entered into a new stage of his life, feeling the need to have a more stable domestic situation. In 1890, he married the young Aline who had posed for him several times. *Le déjeuner des canotiers* (1880–1882) can justly be called the "swan song" of Renoir's impressionist period. The scene was executed *en plein air* on a terrace of the La Fournaise restaurant in Chatou. It is set in an atmosphere of warm intimacy that brings together the artist's friends and acquaintances. They are painted with distinctive features and unique attention is given to the design, a sign of a change underway in Renoir's art moving him toward increased plasticity.

In 1882 Renoir took another trip to Italy. In Palermo he met Richard Wagner the day after the composer had completed *Parsifal*. In their hurried meeting, in which Renoir had little more than thirty-five minutes to paint his

portrait, Wagner—apparently not very impressed by the results—commented: "Ah! I look like a Protestant priest."

The concept of "vacation," it scarcely need be said, for Renoir meant painting all of the time and studying antique art in museums. Renoir's true reason for visiting Italy was to study Raphael's work, whose frescoes he had admired at the Villa Farnesina in Rome. He wrote about it to Durand-Ruel: "I went to see Raphael in Rome. It's a beauty. I should have seen it earlier. It is full of learning and wisdom. I prefer Ingres and the oil paintings. But the frescoes are impressive for their simplicity and magnificence." Unfortunately, Renoir was little satisfied with his own work: "I am still obsessed with experimenting. I'm not satisfied and I erase and I keep on erasing. I hope this obsession passes. I am like children at school … I am forty years old and I'm still sketching." The dissatisfaction felt in these words was caused by a new stage in the painter's development. In his new admiration for Raphael, the epitome of design and classically completed form and his nineteenth-century alter ego, Ingres, Renoir was experimenting with a new horizon for his own art, turning once again to the museum and to tradition (perhaps partly because of suggestions from Cézanne, a figure independent from the impressionists, whom he visited in L'Estaque when he returned from Italy). He managed to extract new life from this tradition and would from then on be open to new formal and compositional possibilities.

At the end of 1883, Renoir took a trip with Monet for a few weeks from Marseille to Genoa, seeking fresh Mediterranean landscape subjects. This would be the last time the two painters would work together. In many ways, they were already quite far apart. Monet was on the path of an increasingly meticulous immersion in nature. Renoir, after the shift that the trip in Italy constituted, having taking in Raphael's frescoes and the wall paintings in Pompeii, sought what he himself called "the great harmonies" rather than "the small details

that block out the sun." In order to do so, he had to give more solidity to the painting, stripping away complications related to the impressionist-type sensory perceptions. He would continue to paint bathers for the rest of his life. This was the most classic theme in painting—returned to later in a unique iconographic and formal symbiosis with the sculptor Aristide Maillol. He went back to working in the studio, in an attempt to reconnect to a tradition that he felt was still alive and well and conferred formal simplification and unity to the composition. This was called his *aigre* (harsh) or *Ingresque* period. His movement past impressionism, which happened over just a few years, had reached its final point.

The Bathers would be the culmination of this new artistic stage. Renoir worked patiently on it for three years. The painting is meticulously considered and pain-stakingly executed. It was shown at the Georges Petit gallery in 1887, and met with great enthusiasm from the Polish scholar Théodore de Wyzewa. Approval could not be expected from the old guard impressionists "I appreciate what he is trying to do. I fully understand that he does not want to stay in the same place, but he did not seek to address anything but the line. The figures are piled on top of one another without considering the color agreements …" wrote Pissarro. Durand-Ruel also did not like the "new style." What's more, the painter himself was not even satisfied with his work in these years. He realized that he was going through a period of stylistic seeking; in 1888 he confided in the art critic Roger-Marx, who was preparing an exhibition in Paris: "I find everything I've done ugly and it would be all the more painful to me to see it exhibited."

Once he passed this dry phase of study, Renoir's first large individual show was put on in 1892 in the gallery of Durand-Ruel, who had meanwhile exposed the work of the impressionists to the foreign market. It was an anthology of 110 paintings, including his most important works to date. It included *Le Moulin de la Galette*, *Le déjeuner des canotiers* and *The Bathers*.

This provided an opportunity to appreciate that Renoir's painting oeuvre as a whole was highly versatile. When considered as a whole, this versatility is seen in his choice of subjects for his paintings (ranging from scenes of *la vie moderne* and domestic life, to landscapes, seascapes, and bathers) as well as in his technique (which moves from palette knife techniques to light brushstrokes, to sharp color contrasts) as well as a wealth of style influences—including Courbet, Monet, and Maillol.

Following events in his life, Renoir's work in the 1890s was infused with a new breath of youth. In 1894 his second child, Jean (the future film director) was born in his new home Château des Brouillards, in the high, still countrified area of Montmartre. To help his wife Aline, Renoir brought in her cousin, Gabrielle Renard, who was sixteen years old. She would become his favorite model for some twenty years. Throughout his entire painting career, Renoir was a steadfast painter of young women. He excelled at rendering their soft, velvety skin in a fountain of light, their limpid eyes and rich, shining hair. Bourgeois women, working women, dancers, seamstresses, all bearing a light grace reminiscent of other feminine beauties painted in the eighteenth century by Boucher, Watteau, and Fragonard.

Soft, gentle lines returned to his paintings during this period with the suffused luminosity that was lost in his *Ingresque* experimenting. The subjects portrayed are often domestic interiors, scenes of intimate family life, women and children in reassuring, timeless atmospheres that easily won over the wealthy market of bourgeois collectors.

In the early years of the twentieth century, only three of the old guard impressionists survived: Monet, who painted in his home in Giverny, nearly blind but very active, surrounded by admirers of his work; Degas, who was also threatened by blindness, and Renoir, with this fingers ever more deformed by arthritis, yet as determined as ever to do the work he had done his whole life. He painted with brushes

attached to his wrists, continuing like in his early years "to put paint to canvas to amuse himself." He moved to Cagnes on the advice of doctors and bought the estate the Collettes—a house hidden in the midst of trees, from which you could see the old village and the sea. He spent the remaining years of his life here. He was so thin that he could not sit for long. He spent nights trembling from pain, then he had himself carried to his easel where he still deftly painted nudes of women and children's faces, despite his bandaged hands. Monet and Renoir now lived far apart, though still immersed in nature. The two friends who had first experimented with *en plein air* painting and started the impressionist era had painted side by side for the last time in 1883 on the trip from Marseille to Genoa. They interpreted nature as they had in the past with the strength of two different temperaments. Monet scrutinized the nymphs in his garden in Giverny and came to results that had an almost formal abstraction; Renoir, with his own sponta-

neous and virtuoso talent, continued to portray nature humanized by the eternal presence of women.

He achieved significant painting synthesis in these last years of his life. He was now removed from impressionism, yet maintained its vibrant influence, though now using it for compositions that no longer had the sole objective of studying nature. He confided in a young man about his difficulties in representing nature while rendering his own feelings when looking at it: "How difficult it is in a painting to find the exact point where the imitation of nature should end. The painting should not reek of the model, but you should smell the scent of nature."

Renoir experimented with sculpture technique as well in the first decade of the twentieth century. The art dealer Ambroise Vollard (who was working on writing the artist's biography) encouraged him to do so and brought Richard Guino, a young Catalan student of Maillol's, into his studio. When he still had free use of one hand, the painter

made some engravings, and then tried lithography and finally even worked at sculpting gesso. The only relief actually sculpted by his hands is a tondo portraying his son Coco Renoir. Other medallions, a high relief depicting the *Judgment of Paris* and the statue of *Venus Victrix* are part of the period when he had lost mobility. He worked with a long cane that he controlled from far away, guiding the hands of Richard Guino.

In the difficult years of World War I—his sons Pierre and Jean went to war and his wife Aline died of a diabetic attack—the old painter stayed in Cagnes. Young artists made pilgrimages to visit him (Henri Matisse was a regular). He spoke of his painting technique, with increasing modesty, avoiding teaching an arbitrary method or absolute directives. Within his life he had had the chance to paint *en plein air* while admiring the careful painting of works made in the studio (his attraction to Corot and Courbet, Ingres and Delacroix can certainly not be explained following a completely consistent logic).

Forty-four paintings by Renoir were exhibited at the Salon d'Automne in 1904. The event was quite important, particularly for young Fauve artists like Matisse, who were deeply influenced by his painting and brought a twentieth-century interpretation to them. Maurice Gangnat, an admirer of Renoir's work, went to meet him after this show and bought a group of paintings, starting one of the major Renoir collections.

Renoir now became an exemplary master for young artists to reference on par with Cézanne and Monet, from whom to learn to find new paths for independent expression. It could be said that Renoir's legacy has been seen more in artistic work than in writings. His vast body of work continued to influence painters for a long time to come (e.g., Zandomeneghi, Maurice Denis, Spadini, and Carena), who would return to take inspiration from that work, rediscovering each instance the timeless happiness that would give new life force to their paintings. Critics, meanwhile, could

not (and cannot) grasp that which Renoir himself, uninterested in all kinds of theory or abstraction, did not wish to put in words. Nonetheless critics followed his career from his first painting to well after his death in 1919.

Renoir's work developed over more than fifty years between the ninetieth and twentieth centuries. It was originally denigrated by Salon critics, and even in more favorable years it was poorly understood in its continuity. This is inarguably due to the constant tension of his artistic pursuit, stripped of intellectual strivings. It was defined rather by what John Rewald called "astonishing ease," the ease with which he seized new challenges and each time surpassed his objectives with his energetic spirit, testing himself anew in each experience, stretching the bounds of color.

The German critic Julius Meier-Graefe wrote the first systematic study of Renoir's work in 1911, expanding it in 1929. The first large catalogue of his works was made in 1913 with a preface by Octave Mirbeau for an exhibition at the Bernheim-Jeune gallery. This was when Mirbeau terms Renoir's life and work a "lesson in happiness."

Important exhibitions were held in Paris in 1933, at the Orangerie, and at the Metropolitan Museum of Art in New York in 1937. The huge interest Renoir (and other impressionists) excited among American collectors would deserve a chapter of its own. It went from initial repulsion (in 1886 an American critic was still denouncing Renoir as a wayward student of Gleyre's), to exuberant instances of collector excitement. Albert Barnes, for instance, was a collector of impressionist works (there are about 200 works by Renoir at the Barnes Foundation in Merion) and an author of an important study (1935) on Renoir's style.

Another essential writing from America is the *History of Impressionism* by John Rewald, quoted earlier, which analyzes writings, letters, and stories from a historic and cultural perspective, narrating the

Vineyards in Cagnes,
c. 1908
New York, Brooklyn
Museum of Art

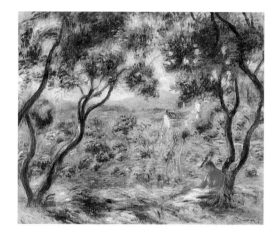

history of its critical reception at impressionist exhibitions.

It is well known that impressionism has always been poorly understood by most in Italy. The critic Diego Martelli showed early interest in Renoir, calling him a "greatly subtle artist" in 1880, but his words were drowned out by the clamor of voices against impressionism and its spread in Italy. It was not until 1908 that more attentive criticism came with Vittorio Pica, who managed to understand the painter's contradictory values and did not stop at seeing him for the brief impressionist period (although it could be easy to misunderstand as the monographic book about the group of painters is called *The French Impressionists*). He successfully grasped the unity of his entire work, in its connection with tradition and its openness to modernity. Pica sensitively saw in Renoir "a painter's nature that was not easily satisfied, a restless, seeking sensibility of his and a spirit of great creative ferment, which would give him the opportunity to apply to himself

Monet's classic affirmation: "Every time I paint, I throw myself into the water to learn how to swim."

When the American painter Walter Pach asked him about his method in 1908, Renoir answered: "I arrange my subject as I want it, then I go ahead and paint it, like a child. I want a red to be sonorous, to sound like a bell; if it doesn't turn out that way, I add more reds and other colors until I get it. I am no cleverer than that. I have no rules and no methods; anyone can look at my materials or watch how I paint—he will see that I have no secrets. I look at a nude; there are myriads of tiny tints. I must find the ones that will make the flesh on my canvas live and quiver. Nowadays they want to explain everything. But if they could explain a picture, it wouldn't be art. Shall I tell you what I think are the two qualities of art? It must be indescribable and it must be inimitable… The work of art must seize upon you, wrap you up in itself, carry you away."

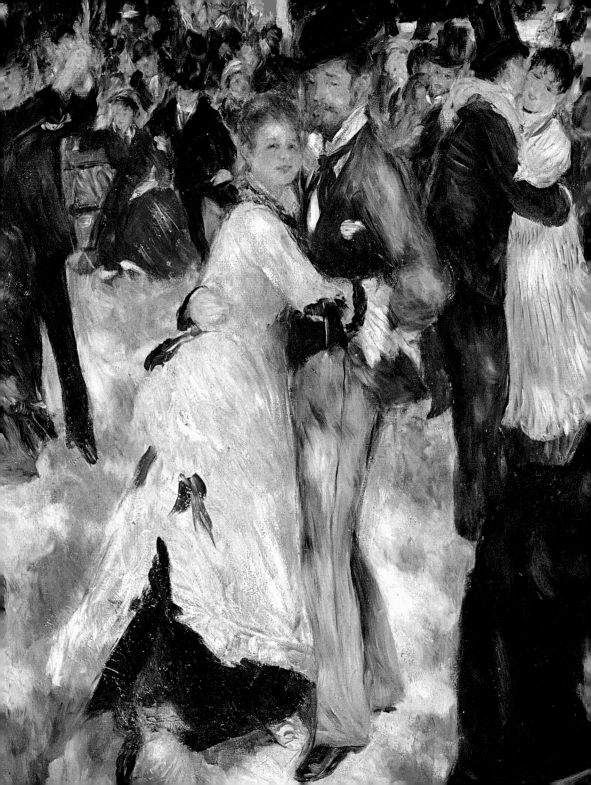

The Masterpieces

Le Moulin de la Galette (detail),
1876
Paris, Musée d'Orsay

Portrait of William Sisley

1864
Oil on canvas, 81 × 65 cm
Paris, Musée d'Orsay

Renoir showed this portrait of his friend Alfred Sisley's father at the Salon of 1865 after his first success at the Salon the year before with his painting *Esmeralda Dancing*. The artist went on to destroy this success when, after becoming part of Impressionist poetics, he moved past this brief early phase still tied to literary themes (the subject was based on Victor Hugo's *Notre-Dame de Paris*) and academic painting.

In all likelihood this portrait was commissioned by Alfred Sisley—whom Renoir met at Gleyre's studio along with Monet and Bazille—intent on helping his friend, of abundant talent but slender means. William Sisley was a businessman born in France in 1799 of an English father; he died in the early 1870s. Little is known of him, but it is thought that he gave his son Alfred a quite liberal education, letting him dedicate himself to painting despite the lack of precedents for it in the family.

Through the painting's relatively plain composition and color range, Renoir gives his friend's father an intentionally austere look. The right hand lifted to hold his glasses is the only element that lightens the rigid symmetry of his pose.

Renoir returns to a model of neoclassical, Ingres-style portrait painting (see, for example, Ingres's *Portrait of Monsieur Bertin*), proving his extraordinary painting talent in the studied tonal passages on the subject's face. The warm tones of the finely modeled skin bring out the face, separating it from the dense black of the jacket and the indistinct brown background. The essential composition and the choice of the half figure accentuate the portrait's official aspect, still a ways off from the vivacious, fluid freedom that would come in Renoir's later portraits.

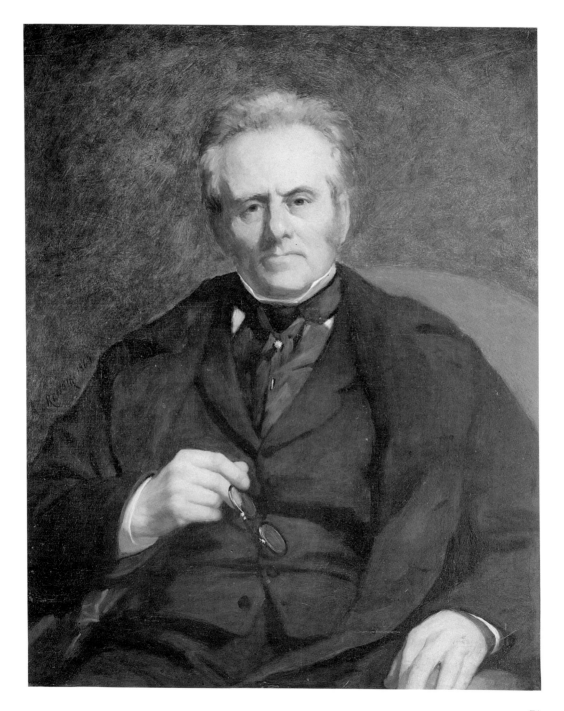

Portrait of Bazille

1867
Oil on canvas, 106 × 74 cm
Paris, Musée d'Orsay

The year before Renoir painted this portrait saw him struggling to sell his works (his *Landscape with Two Figures* had been rejected by the Salon's jury). Finding himself in serious financial difficulties, he found hospitality and moral support in the studio of his friend Frédéric Bazille, dedicated to similar painting pursuits. The next year Claude Monet joined the pair (as he was likewise struggling to sell his work). The fruits of the three artists living together were abundant as we can see in the numerous paintings by the three friends on Bazille's studio walls. Their companionship was abruptly halted with the outbreak of the Franco-Prussian war. Bazille enlisted as a volunteer in August 1870 and died on November 18 in the battle of Beaune-la-Rolande.

Renoir painted his friend in his studio on Rue Visconti while he was working on the painting, *The Heron* (today in Montpellier's, Musée Fabre). A winter landscape by Monet, *La route de la Ferme Saint-Siméon en hiver* (c. 1867), can be glimpsed in the background. It seems that Bazille's studio was also frequented by Alfred Sisley in this period, as a similar painting by Sisley takes up the same subject of the heron that Bazille is painting in this portrait.

The portrait vividly expresses the chaotic lives of these young bohemians, absorbed, like Bazille here, in their formal experiments. The freshness and ease of the brushstrokes in the scene shows new spontaneity and an atmosphere of "real life" quite unlike the *Portrait of William Sisley* (intended for the official public of the Salon). Its relatively limited color range, tending toward monochromes in grays and browns, is reminiscent of Corot's portraits.

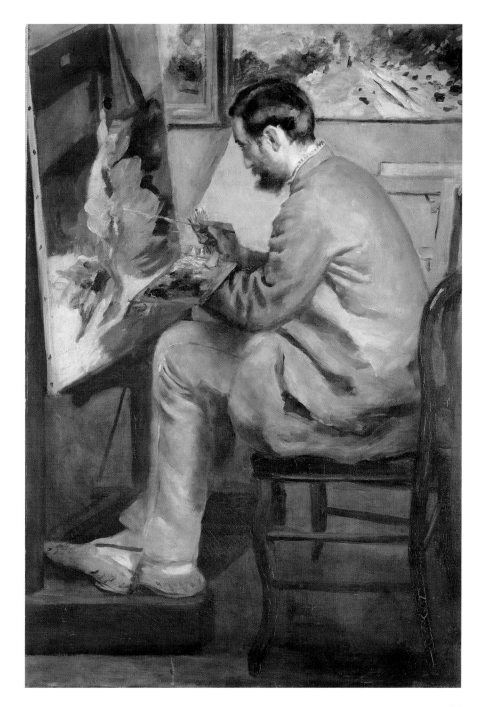

Lise with Parasol

1867
Oil on canvas, 184 × 115 cm
Essen, Museum Folkwang

L ise Tréhot was Renoir's favorite model between 1865 and 1872. We can recognize her features in many of his paintings from this period, including *Girl Sitting Outside* (1869), *A Nymph by a Stream* (1869) and *An Algerian Woman* (1870). *Lise with Parasol* was painted while he was visiting Chailly, in the Fontainebleau forest, where he spent the spring with Lise and his friends Sisley and Le Cœur, practicing painting outdoors (following the footsteps of the Barbizon masters).

This painting reveals the influence of Courbet's work on Renoir, especially Courbet's *Village Girls* shown at his individual show in 1867. The influence of Manet and Monet is also clear, particularly if we consider Monet's monumental painting, *Women in the Garden* (1866–1867), rejected from the Salon the year before.

Lise's dress is evidence of the success of Renoir's light studies during this period. Its black train shimmers with light reflections; the large dress is divided in areas of shadow in the upper part, while the transparent sleeves reveal the model's plump arms.

Critical reaction seemed favorable. The critic Thoré-Bürger admired the light effects of the dress and proposed the theory that color changes depending on the colors that surround it (the idea at the core of Chevreul's optical studies and essential for Seurat and Signac's pointillism). Julius Meier-Graefe remembered this portrait as an image from a dream: "Its many shades of white contain all of the enchantment of contrast in themselves, not to mention the powerful opposition between the majestic black of the scarf and the red of some of the details. [...] Yet all of these tones only appear when you look for them. They disappear when you realize it's a dream, the White Lady in the shadow of the forest."

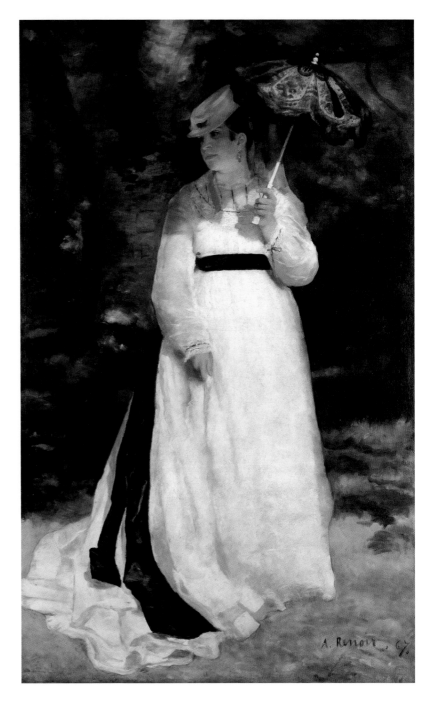

La Grenouillère

1868
Oil on canvas, 59 × 80 cm
St. Petersburg, The State
Hermitage Museum

The Grenouillère was a resort on the banks of the Seine and one of the most popular places for the Parisian bourgeoisie of the day to spend their free time. This is where the painting style that would come to be called impressionism came into existence through Renoir and Monet's studies of light. Both focused on using quick brushstrokes to capture scenes of *la vie moderne*, of which Baudelaire spoke in one of his famous art reviews of the Salon of 1846: "The heroism of modern life surrounds us and envelops us." Later he wrote: "Modernity is the transient, the fleeting, the contingent; it is one half of art, the other being the eternal and the immovable."

Renoir painted many works dedicated to the vivacious expression of modern *amusement*, such as the famed *Le Moulin de la Galette*, *Dance in the City*, *Dance in the Country* and many more.

An artificial island crowded with people is the center of the composition. Some bathers and boats are glimpsed to the right and a corner of a restaurant is to the left. This painting, compared to Renoir's earlier works, has a particularly sketchlike feel. Renoir just barely suggests the individual subjects while his attention is clearly focused on the water surface, which reflects the sunlight and surrounding nature with bright, shimmering colors. Quick lines, dots, and rapid spots of color capture a sparkling summer day, the movement of the water, the bather's gestures, with the intention of reproducing the impressions and sensations perceived by the eye. Monet was more involved in strictly visual phenomenon and gives the same scene an analytically structured representation, while Renoir's interest was to render the scene's vivacity, the warm, leisurely atmosphere of the place.

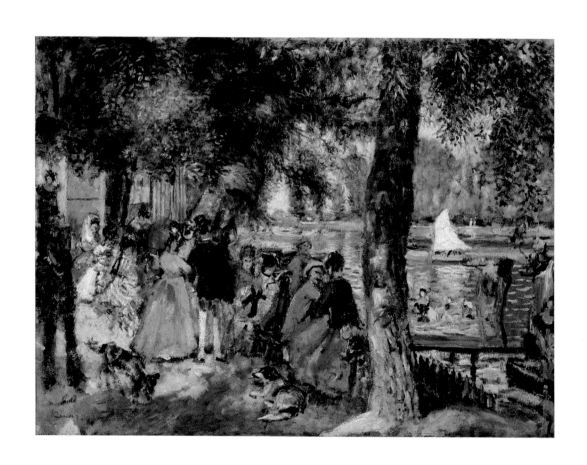

Sisley and His Wife

1868
Oil on canvas, 105 × 75 cm
Köln, Wallraf-Richartz-
Museum

Renoir and Sisley had been close friends since they met in Gleyre's studio in 1862. The features of the painter, who was of English origin, are also to be seen in *The Inn of Mother Anthony*, in which Sisley is sitting at the table in the foreground next to the painter Jules Le Cœur.

In all likelihood, this work was painted when the two painters were staying at Chailly in April of 1868. The landscape in the background is vague and insubstantial, having little importance for Renoir, who focused his attention on the two figures dominating the foreground. The couple is captured in a casual pose, almost like in a snapshot. The seemingly static pose of the two is broken by the young wife, Marie, who grasps her husband's arm while looking timidly at the viewer with a strong effect of immediacy.

Marie (whom Sisley had married two years earlier) is clearly the focus of the composition. Her voluminous, brightly colored skirt takes up a large part of the painting, giving a touch of monumentality to a work that otherwise conveys a confidential tone.

Renoir remembered the masters who influenced him during this period, saying, "Courbet still meant tradition; Manet meant opening to a new era in painting." This work was one that showed the influence of Édouard Manet's methods. The contour of the pants is reminiscent, Manet's *The Fifer* (1866), which the young painter had copied in a drawing, while its large black surfaces recall Velázquez's painting, which Renoir came to know through the experience of Manet.

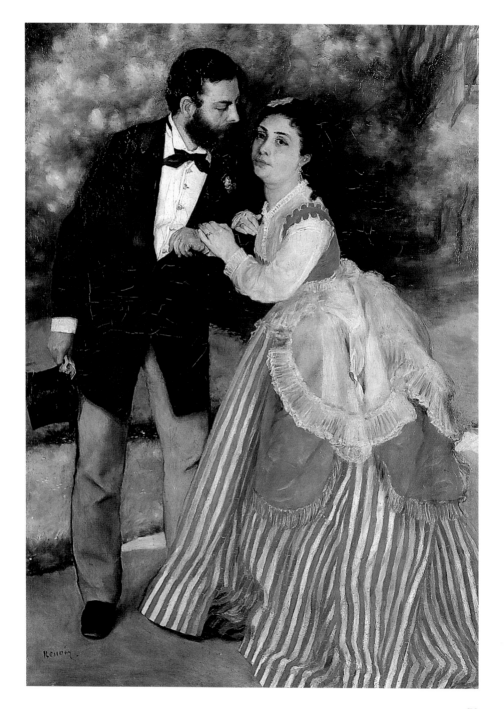

Claude Monet Reading

1872
Oil on canvas, 61 × 50 cm
Paris, Musée Marmottan
Monet

In the 1860s and early 1870s, Monet and Renoir's artistic bond verged on symbiotic and was highly productive. Their direct dialogue in *La Grenouillère* (1868) gave the new impressionist language one of its earliest expressions.

After Monet came back from Holland and England, where he took refuge during the Franco-Prussian war, Manet helped him and his wife Camille rent a small house in Argenteuil near Paris where Renoir often visited to paint together with his friend. *Claude Monet Reading* is a result of one of these visits. The two painters would set up their easels side by side and paint the same subject from the same point of view. Forty years later they would at times not even themselves be able to distinguish who painted which works.

Monet's relaxed pose, captured while he is absorbed in reading the newspaper and smoking a pipe, speaks to how close the two friends were. This portrait was one of many Renoir painted for his friend (e.g. the *Portrait of Claude Monet* with the palette) and became part of Monet's personal collection.

Despite the apparent speed of the brushwork, Renoir lingered on the careful description of specific details, such as Monet's reddish beard and his smoking pipe, enlivening the dark colors of his clothes and the background with yellow threads and touches and the red in the pipe and arm of the chair. The lighting of the interior and the scene accentuates Monet's face and hand, bringing him dramatically near to the viewer with a close-up focus.

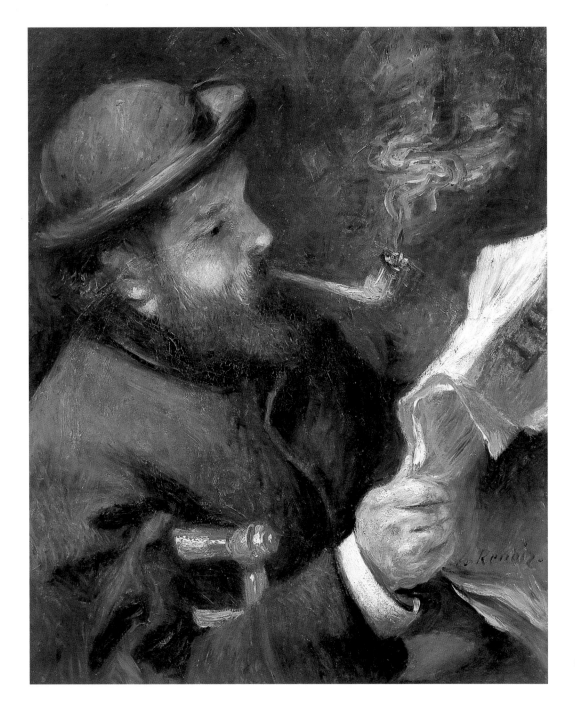

The Seine at Argenteuil

c. 1873

Oil on canvas, 46 × 65 cm

Paris, Musée d'Orsay

In 1868, as mentioned, Monet and Renoir worked side by side at La Grenouillère, painting the same subject. Once again, in 1873 and 1874, they came to work together and painted almost identical views of the Seine at Argenteuil. Although there are some differences between the paintings, both artists approached the idea of painting the Seine with the same pioneering spirit. They set up their easels on the river's banks near the Argenteuil bridge and, with the zeal of neophytes, studied the reflections of the sun on the water, seeking to chromatically render the light with fluid, rapid brushstrokes. Throughout his life, Monet would see the world as reflected in water, the image in an image, reflected through a magic prism, which would later lead to almost abstract compositions, such as *Waterlilies* painted at Giverny. Renoir would instead concentrate on details, and—as seen in *La Grenouillère*, especially on people. Renoir's choice is clear even in the name he gave the place, as the word *grenouilles* refers to young women who spent summer Sundays with their men in this leisure spot.

In this painting, however, there is no human presence. Instead there is a landscape painted with a fluid, sketched material quality, which can be compared to his early *en plein air* works, such as *The Seine at Asnières*. At that point, his color register was enriched with lighter shades and made less weighty with grays and thicker brushwork, a trait inherited from Courbet.

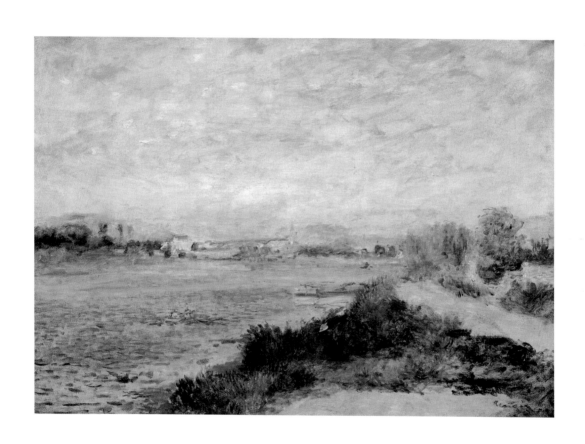

The Theatre Box

1874
Oil on canvas, 80 × 64 cm
London, Courtauld Institute
Gallery

A model from Montmartre nicknamed Nini "Gueule de Raie" and Edmond, the painter's brother, posed for this painting, presented at the first impressionist exhibition in 1874.

The choice of subject makes this work unique. An opera box, clearly not an outdoor scene like many of the works shown at Nadar's that year; a slice of worldly Parisian life during the Belle Époque, familiar to us from Degas's works. Although the painting was done in the studio before deliberately placed models, it still has the freshness of works painted in the spur of the moment, giving the illusion of great immediacy, a photographed instant.

The painter lingered over the opulence of the fabric of the woman's dress, contrasted with the delicate tone of her skin (emphasized by the rose in her hair). He used light touches of color to outline details such as her sparkling earrings and the roses pinned on her chest. The figure of the man is painted as one with that of the woman. The black stripe of her clothes becomes part of her companion's jacket. Yet the two characters do not look at each other. He is looking outside of the box with binoculars. She is bending and looking at the painter's viewer with a direct gaze, as if expectant.

The critic Roberto Longhi called it, "perhaps the happiest painting of the modern era." *The Theater Box* is striking for the immaterial rendering of fabrics, details, and the figures, who through a deft use of color contrasts lose none of their concreteness and indeed gain added appeal for their observers.

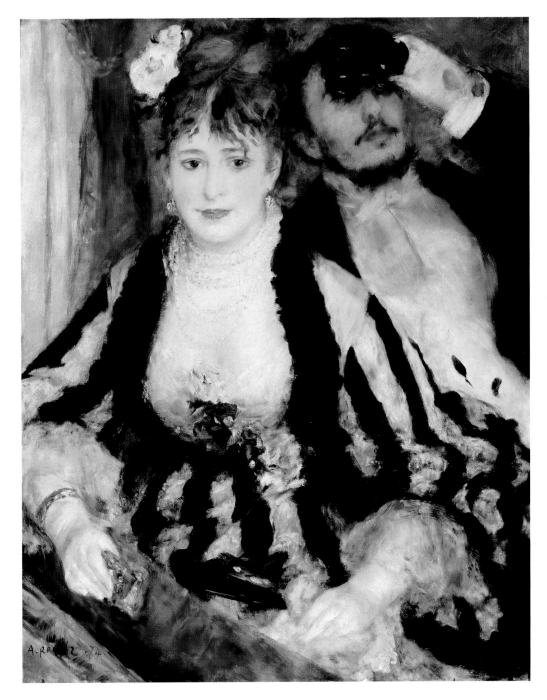

Path Leading through the High Grass

c. 1874
Oil on canvas, 60 × 74 cm
Paris, Musée d'Orsay

This painting represents one of the highlights of Renoir's impressionist period. It seems the result of a view flooded by sunlight, an attempt to chromatically render the light of a bright, sunny afternoon.

Though there are issues with dating—alternately in 1874 (when Renoir was in Argenteuil with Monet), or 1876–1878 (when he painted masterpieces such as *The Swing* and *Le Moulin de la Galette*)—it can be chronologically associated with *Poppies*, which Claude Monet painted in 1873, with the same subject and composition of the figures in the landscape. Both paintings show two figures on top of a hill and two figures below who are nearing the observer with a similar effect of a sense of movement downwards along the path.

Renoir uses the intense red of the poppies with which he dots sections of the canvas to raise the overall intensity level of the color range, strongly contrasted with the dark green of the bushes and trees in the second ground. The color of the woman's parasol is another note of red related to the red spots in the foreground. The overall effect of the painting draws on the high tension between the spatiality suggested by the path between the fields and the absolute insubstantial quality created by rapid brushstrokes used to render the vibrant effects of light.

This may have been the summer landscape sold in 1875 for the paltry sum of 105 francs to the Hôtel Drouot at the auction organized by Renoir and Monet to try to help them out of their serious financial situations. As the art dealer Paul Durand-Ruel, who was close to the impressionist group, could not buy the works of his friends for himself, he watched Renoir's paintings go, bought at rock-bottom prices, scarcely enough to cover the cost of the frames (in which the purchasers were probably more interested).

Portrait of Charles Le Cœur

1874
Oil on canvas, 42 × 30 cm
Paris, Musée d'Orsay

In 1874, Renoir stepped definitively into the *nouvelle peinture* with his *Portrait of Charles Le Cœur*. He sketched the figure with wide brushstrokes and loose touches of fluidly applied paint, creating a dynamic portrait of his architect friend, Charles Le Cœur (1830–1906), who supported him at a time when customers were hardly pounding down Renoir's studio door.

During these years, Le Cœur was receiving government commissions and building opulent homes for high society. He built the home of Prince Bibesco (who became an important protector and patron for Renoir) on Avenue de La Tour-Maubourg, for which he gave his friend Renoir the job of decorating the interiors with panels (the paintings were destroyed in 1911 when the building was renovated). Unfortunately for Renoir, this friendly and profitable relationship came to an abrupt end. Renoir had made advances to Marie Le Cœur—his friend's oldest daughter, sixteen at the time—and was quickly thrown out of the architect's home the very summer this painting was completed.

The note on the top left of the painting, "ô Galand Jard" ("*Au Galand Jardinier*"), is a dedication to his friend, portrayed in his garden in Fontenay-aux-Roses in a relaxed pose as he smokes standing before the painter. The background is undefined; a barely sketched door and a wall are glimpsed. The paint is spread fluidly to give the wall flatness from which the figure stands out with a brighter white. The painting is a succession of rapid brushstrokes that overlap to capture the immediacy of the scene to great effect and virtuosity.

89

Madame Monet Reading

c. 1874
Oil on canvas, 53 × 71 cm
Lisbon, Museu Calouste
Gulbenkian

Renoir painted this work during a stay with the Monets at Argenteuil, where he went many times in 1874 to paint landscapes and figures on the Seine alongside his friend. He made many paintings of his friend Claude reading and his wife, Camille, with her child playing outside. He often gave the paintings to his friend as thanks for his hospitality. Monet gradually formed a small collection of portraits of Camille, painted by himself and by Renoir. The three shared a special friendship. Claude's realistic outlook, Camille's serenity and charm, and Renoir's easy, carefree nature provided them years of great accord, summers in a placid, familylike environment, standing with palette and easel in the fields (see *Path Leading through the High Grass*), and on Claude's boat set up to serve as a floating studio. Édouard Manet occasionally joined the group. Stealing glances at Renoir's canvas, he could not stop himself from making comments to Monet that smacked of a certain rivalry (it certainly must have been awkward painting the same subject side by side): "That boy has no talent … You're his friend, please tell him to give up painting!"

The painting is very fluid and hazy. The subject's features are barely suggested by rapid brushstrokes. The painting is based entirely on color contrasts, which recompose the disordered movement of the individual parts—such as the vivid jumble of color that forms the dress's pattern—to create an overall balance in the eye of the beholder.

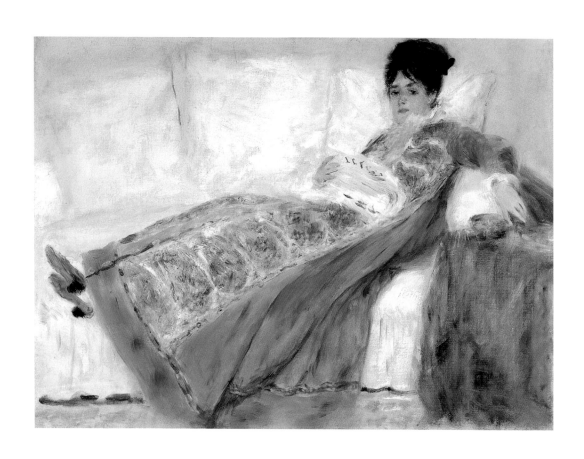

Portrait of Claude Monet

1875
Oil on canvas, 84 × 60 cm
Paris, Musée d'Orsay

This portrait was shown in 1876 at the impressionists' second exhibition along with fourteen other paintings including the famed *Nude in the Sun,* which drew sarcastic remarks from critics.

Compared to the drastic newness of that painting, this work's composition is more restrained; with more measured tones. A window provides the source of light, giving the painting a suffused luminosity rather than the bright, radiant light of the *plein air* of *Nude in the Sun*. The light filters through a thin curtain—a wonderful passage in the painting—and illuminates Monet's shoulders.

Renoir portrays his friend with the tools of his art, his palette and paintbrush, whose golden yellow contrasts with his dark suit. The pose here is more conventional than *Claude Monet Reading* from three years earlier, and the composition is notably less dynamic. Renoir always moved with great ease between modes of working —whether more finished or more off-the-cuff—alternating them at will. This portrait's vibrancy is achieved with painting that works through subtle light gradations and gentle rhythmic modulations. In other cases (in addition to *Claude Monet Reading*, see the wonderful *Portrait of Charles Le Cœur*) it is rapid brushwork and a remarkably daring color register that render an effect of greater immediacy. Monet and Renoir, who had met at Gleyre's studio, painted shoulder-to-shoulder many times throughout the 1860s and 1870s in Bazille's studio, at La Grenouillère, and in Argenteuil. They shared the experiences of bohemian life, *en plein air* studies, and the public unpopularity of the paintings that came out of these studies.

Nude in the Sun

1875
Oil on canvas, 81 × 64 cm
Paris, Musée d'Orsay

At the second impressionist exhibition in 1876, the critic Albert Wolff called *Nude in the Sun* in *Le Figaro*, "a mass of decomposing flesh, with green and purple patches like a corpse in a state of utter putrefaction!", unwittingly placing the focus on the luminous mobility that moved Renoir's painting in these years as he worked with the refraction of colorful shimmers and sudden flares of light.

A girl named Anna modeled for this work, painted as a bather resting from the sun. Splashes of light come through the foliage on the woman's body; shadow tones model her curves, awash and caressed by the sun. It is not difficult to fathom the shock felt by reviewers of works such as this. There is no line nor contour and the local colors of the skin are completely overwhelmed by the effects of light. The woman's face and body are constituted of green-pink hues; the surrounding landscape is undefined, suggested by rapid, green and blue brushstrokes. Here again, in Renoir's *plein air* observation he is not interested, like Monet, in nature in and of itself, in the lights it contains and reflects. He is interested rather in the figures immersed in nature, the colors that bodies take on when lit by the sun through leaves. We could say that the specific contribution Renoir gave to the impressionist concept was in presenting a new idea of landscape, from here on out humanized and subordinated to the figures that are reflected in it (see, *Under the Arbor*, *Le Moulin de la Galette*, and *The Swing*).

The Reader

1875–1876
Oil on canvas, 47 × 38 cm
Paris, Musée d'Orsay

The model here, Margot (Marguerite Legrand), from Montmartre, appeared in many of Renoir's paintings throughout the 1870s (see *Head of a Young Woman*). Her death from typhoid fever in February 1879 was a cause of great sorrow for Renoir. He remembered her as "having skin that reflected light" and tried to render this effect using strong color to brighten her face.

For this painting, which would become part of Gustave Caillebotte's collection, Renoir used a mix of rather uncoordinated colors, threadlike brushwork, often juxtaposing large swaths of complementary colors with strikes of the palette knife. We see the blue-green area in the right part of the canvas next to a unified yellow and pink area behind the model's head; the skin of her face is interrupted by dramatic touches of yellow brushstrokes. Renoir held firmly to the precepts of impressionism in this work. The painting is rapid, made of light and color with little attention to line (see, for instance, the two simple black lines with which Renoir rendered the downcast eyes). The work appears as if it were an image of an instant photograph taken on the spot by the painter seeing a subject that enthralled him. In reality, the composition was carefully considered in his studio and contains echoes of a similar *Liseuse* by Fragonard; the same light reflects from the book's pages and lights the two readers' foreheads in similar fashion. The subject of a woman reading would be recurrent in Renoir's work. Other Renoir *Liseuses* would include Madame Monet and Madame Chocquet. Yet, once again, the subject is a mere pretext for painting feminine grace, the sweetness of rosy skin, and the light reflecting on it.

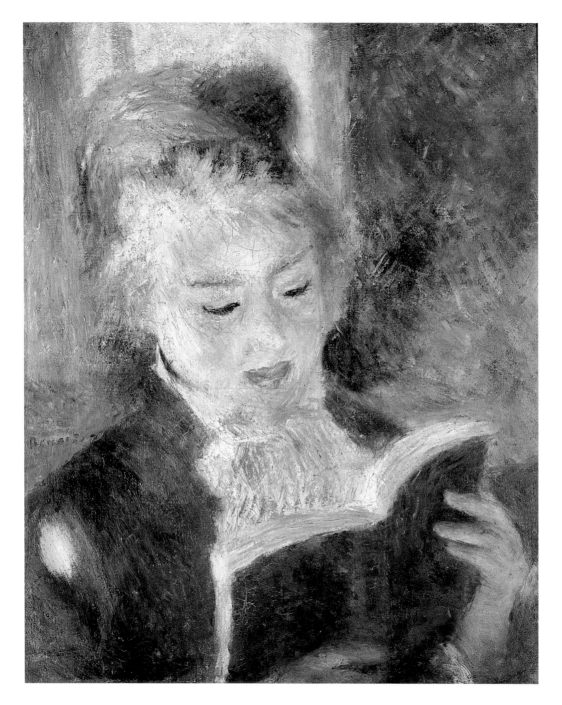

Under the Arbor at the Moulin de la Galette

1876
Oil on canvas, 81 × 65 cm
Moscow, The Pushkin State
Museum of Fine Arts

This painting is from the period when Renoir was preparing his large painting *Le Moulin de la Galette*. Having set up at the location, he studied the environment, the light, and the features of the people. In April 1875 he rented a studio in Rue Cortot in Montmartre consisting of two enormous rooms, a storage area to collect his finished paintings, and a garden. He then started to work on a series of studies and sketches of the Moulin de la Galette, a popular recreation spot for Parisians.

The work, formerly in Eugène Murer's collection, shows a group of men sitting at a table with a woman, engaged in drinking and flirting with her, observed by a female figure who, given her similar clothes and hairstyle, might be Estelle, the model who would pose in the foreground of *Le Moulin de la Galette*. The scene is an example of the type of painting which would later meet with great success among the bourgeois public, especially in the American market, which critics termed Renoir's "Romantic Impressionism," typified by portrayals of bourgeois loves; lovers at a dance or in a garden, scenes like this that depicted pleasant gatherings of friends on holiday at places such as the Moulin de la Galette, Bougival, and Chatou.

Facial expressions and clothing details are suggested by wide brushstrokes and the filtering of the light through the tree's leaves is rendered with brief *taches* that give the painting movement. The woman on the left wears a white, blue-striped dress, creating a kind of theatrical curtain. With her umbrella she gently frames the scene and introduces the viewer into the area in shadow where the gallant courting is taking place.

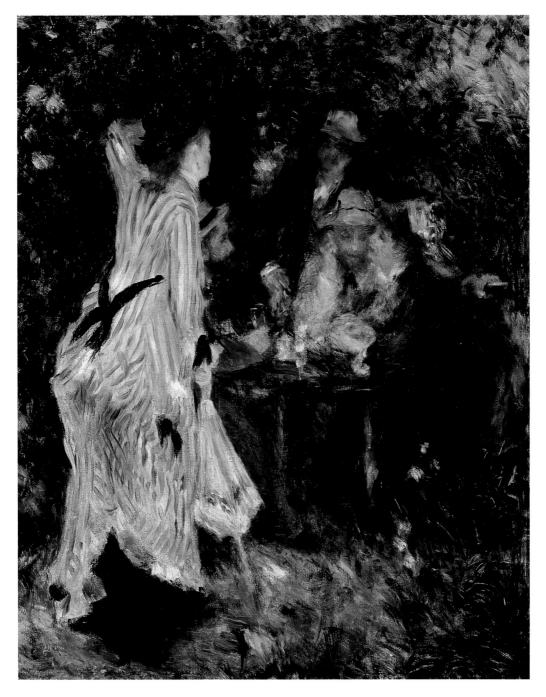

Le Moulin de la Galette

1876
Oil on canvas, 131 × 175 cm
Paris, Musée d'Orsay

This painting, notable for its size and the effort put into it, came out of months of work in 1876 in Montmartre. Friends helped Renoir move the painting every day from his studio in Rue Cortot to where he set up to be closer to the subject he wanted to portray at the Moulin. This is the most complete version of the painting. It was exhibited at the third impressionist show in 1877 and later belonged to Gustave Caillebotte, one of the leading collectors of the new painting style.

During those years, the Moulin de la Galette was a gathering spot where artists and those who lived in the neighborhood gathered to have fun and dance. Renoir, a master at painting *la vie moderne*, lightly rendered the atmosphere of bourgeois pleasure.

Many of the artist's friends posed as models for the dancers and the group of painters in the foreground, gathered around Georges Rivière (a critic who was very favorable to Renoir). Sitting at the table in the foreground is the model Estelle, and to the left is his favorite model of the time, Margot, who is dancing clasped to the Spanish painter Pedro Vidal de Solares y Cardenas. The painting's space is constructed of tones and colors that translate the effects of light. It is remarkable how Renoir used only color, and not dark tones or shadows, to render the reflection of the sun on the faces and clothes of the figures, shaded with pink and blue. The dissolution of form that this created was misunderstood by a critic in the *Moniteur Universel* who laughed at the dancing figures "on a surface like purple clouds that darken the sky on a stormy day." When the painting was exhibited the critic Georges Rivière alone heralded it as "a page of history, a precious monument of Parisian life depicted with rigorous exactness."

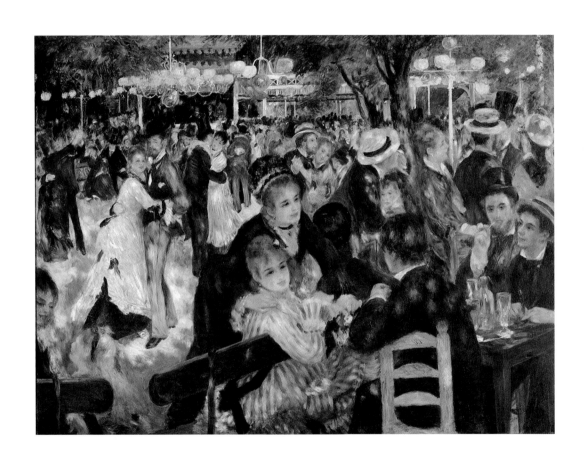

La balançoire
(The Swing)

1876
Oil on canvas, 92 × 73 cm
Paris, Musée d'Orsay

This work was painted in the garden of the Rue Cortot studio in the same period as *Le Moulin de la Galette* and was also shown at the third impressionist exhibition in 1877 and became part of Gustave Caillebotte's collection.

The subject is captured *en plein air* where conditions are ideal for experimenting with the impressionist painting technique. The paint is spread in small spots to render the effect of the sunlight filtered through the leaves. The yellows and blues form the painting's base colors, juxtaposed in alternation, creating an overall atmosphere of color and light vibration, a forerunner of Seurat's experiments to come in the following decade.

The model is the young actress Jeanne Samary who languidly rests on the swing while looking off in the distance. Her dress serves as a wonderful pretext for representing the bright vibrations of light filtered through the foliage. Renoir painted the actress many times. Two of the most famous examples are *La rêverie* and *Portrait of Jeanne Samary*.

The painting made a strong impression on Émile Zola, who seemed to take inspiration from it in his novel *Une page d'amour* (1878) when he wrote: "She wore a gray dress decorated with mauve ties; that day in the limpid sky the sun produced a light yellow dust: a slow shower of rays came through the bare branches."

103

Young Woman with a Veil

c. 1876
Oil on canvas, 61 × 51 cm
Paris, Musée d'Orsay

Variously dated (between 1875 and 1877), this painting depicts a female figure in profile who turns her gaze timidly toward a place unknown to us in the painting's dark background. The veil delicately wraps around the woman's face—a wonderful piece of illusionistic painting—and seems to symbolize the scene's intimacy. The painting's compositional lines follow a geometric plan easy to ascertain: a vertical cut separates the background into two distinct color areas, while in the foreground the woman's shawl forms a triangle with black and yellow checks. Black dominates the painting with considerable weight, following the example of Manet who had paid homage to this color with well-known paintings.

The work is without spatial depth. Excepting the hands, the figure of the woman seems to be a flat surface. Among the small touches with which Renoir lightens the painting's background is the frequent appearance of the rough surface of the canvas showing through. It is clear that the painter—and this is the innovation of his art—does not at all try to create an optic illusion. The canvas is treated as a flat surface on which he spreads his paints according to balances and contrasts within the painting. Impressionist painters were less interested in the realistic rendering of the subject and more in studying the light and colors in their contrasts and harmonies, in their shimmering reflection on human figures, fabrics, and clothing. In this painting, Renoir's inspiration is again a woman, here captured in a framing that accentuates the grace of the pose, the lost profile of a figure that appears mysterious to us.

105

Woman in Black

c. 1876
Oil on canvas, 63 × 53 cm
St. Petersburg, The State
Hermitage Museum

Renoir sets the pale face of an unknown woman in the center of the painting, her face just barely brightened by a trace of red makeup on her lips and cheeks. Only with difficulty can we distinguish the transition from the woman's chin to her neck in the portrait's large white surface, painted in a single color tone. The woman's pale white skin is handled with close attention to its shaping. Renoir's vast body of work includes many women's faces with the delicate fragility of porcelain. The lack of chiaroscuro effects in the face contrasts with Renoir's rapid and allusive rendering of the woman's clothes, her white sleeves, and blue scarf, which suggest an impromptu painting based on an instant impression. The allusion to the wallpaper with individual blue flowers on a gray background is equally casual and brief.

With the variations in his technique that switches from brief to descriptive and attentive to detail, it is as if Renoir were taking the observers by the hand and showing them precisely the parts that captured his attention. In this painting, it is the woman's eyes, her lips, her jewelry, and elements such as her elaborate sleeves on which the rays of light linger. For the other parts, he stops at mere suggestion, alluding to them without any linearity or pre-planned layout. This total, instinctive freedom and ease in painting is one of the defining features of Renoir's style, giving us the impression of a painter who takes great pleasure, almost amusement, in his work.

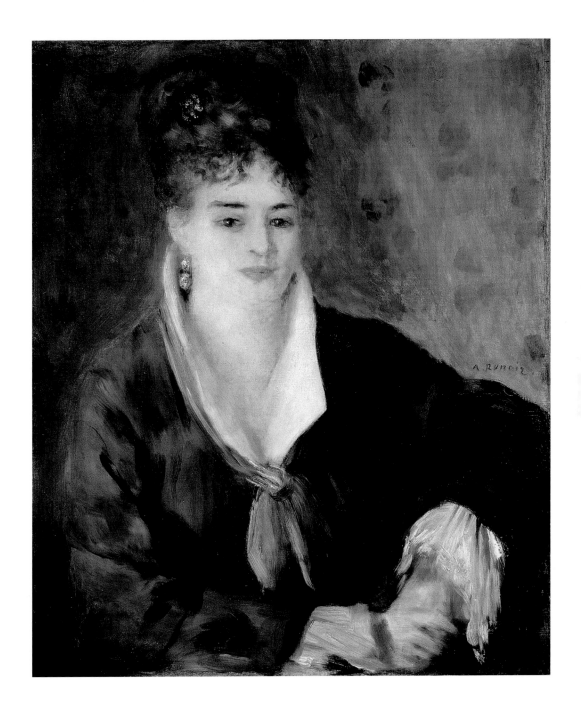

Nude Woman Sitting

c. 1876

Oil on canvas, 92 × 73 cm
Moscow, The Pushkin State
Museum of Fine Arts

This painting, which was part of the composer Émanuel Chabrier's collection, was probably painted in the Rue Saint Georges studio. It represents a genre that Renoir would never truly abandon, even though in these years his intentions were closer to Claude Monet and his *en plein air* study of light.

The model, Anna, has the pale skin and voluptuous body that the painter favored, like that of Aline Charigot, who was to become his wife. Renoir portrayed her sitting in a chair, surrounded by fabric in a relatively dark room.

The background consists of a disordered array of fabrics in a light color to emphasize the woman's body. Its composition is carefully studied with her face gazing past the viewer's shoulder in a provocative pose that partially hides her nudity. Her position is reminiscent of women painted a century earlier by Boucher and Fragonard, while the elegant curve of her back hints at Ingres and Delacroix's odalisques.

Yet Renoir's painting has none of the preciosity of any of its possible iconographic models. The grays and blacks of the background and the far from pure whites of the fabrics are painted with the aid of the palette knife, and undoubtedly can be interpreted as distant echoes of the material quality of Courbet's painting.

The young woman's face is at the painting's center. It porcelainlike delicacy is achieved by the pure white of her skin (the only part in which Renoir chose to not mix the white with other colors), which emphasizes her lips and rosy cheeks. The painting's composition places her head as the crown of a triangle formed of the lower edge of the painting, her back, and her arms.

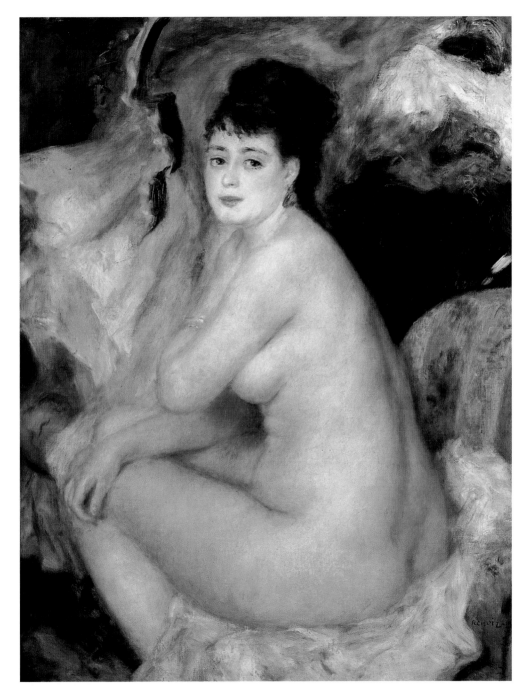

Portrait of Madame Charpentier

1876–1877
Oil on canvas, 46 × 38 cm
Paris, Musée d'Orsay

Marguerite Charpentier was the wife of Georges Charpentier, owner of the publishing house Bibliothèque Charpentier. Much of the *crème de la crème* of Paris's intellectual and political worlds gathered in Madame Charpentier's parlor. Its habitués included Zola, Daudet, Edmond de Goncourt, and Flaubert from whom Renoir received several commissions after joining the circle. Renoir came to be part of a new social milieu, that of his patrons— publishers, intellectuals, art dealers—members of the upper classes. His portraits confirmed their status and provided a reassuring idealization of their lives. This eased Renoir's struggles and his painting took on a new worldly tone, far from the *en plein air* views of Montmartre.

Discerning a certain similarity to Marie Antoinette in Marguerite Charpentier, in this painting (shown at the third impressionist exhibition in 1877) he gives her something of a regal air with her stately face and aloof expression. In his highly differentiated treatment of the different parts (all, however, intent on rendering the sense of the materials) Renoir displays his unique virtuoso skill in painting. The lightweight brushstrokes with diluted paints on the shirt; the finely wrought shaping with whites and yellows of the flower on the back of the jacket; the meticulously descriptive rendering of the woman's face and ears; the rapid painting—with parallel *taches*—of the background. These painting elements all fit into an excellent compositional and chromatic balance. It is in this that Renoir's merits go well beyond mere technical mastery.

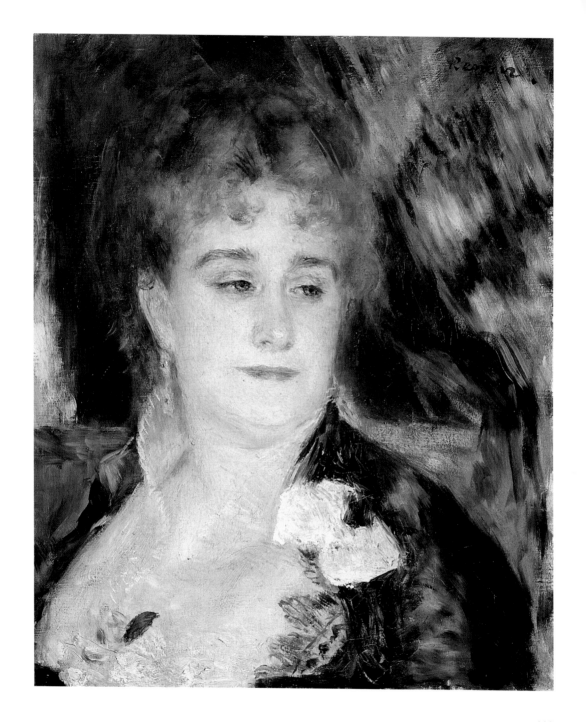

Jeanne Samary
(La rêverie)

1877
Oil on canvas, 56 × 47 cm
Moscow, The Pushkin State
Museum of Fine Arts

The woman in the portrait is Jeanne Samary, an actress who began her career very early, entering the Conservatory at fourteen years of age, winning her first theatrical award at eighteen and quickly becoming the *enfant gâtée* (spoiled child) of French theater. At the time of the painting her fame in Paris equaled that of Sarah Bernhardt. Over the course of three years Renoir would paint her portrait at least twelve times, and saw her as *la petite Samary, qui fait la joie des femmes et surtout des hommes* (the little Samary who brings joy to women and, especially, to men). In 1880, their association was broken off as the actress came to prefer certain painters of the Academic school (Bastien-Lepage and Carolus-Duran) to Renoir. They were masters of official portraits and had different ways of making her shine in the public eye.

This painting, which is also known as *La rêverie* for its subject's soft, dreamy air, was exhibited at the third show of impressionist paintings in 1877 and met with some critical approval. According to Zola, "the success of the exhibition is Mademoiselle Samary's face, all blond and smiling." Here Renoir succeeds in a lightweight painting, almost lacking any chiaroscuro contrasts, consisting of short crossed brushstrokes. The woman's face is without question the focal point of the composition, emerging from the fineness of Renoir's execution and the careful description of her dreamy gaze.

Nonetheless, the work also received several negative reviews by academic critics more concerned with the realistic rendering of anatomical details than the impression of the whole. Moreover and more importantly, it seems that the portrait sitter herself was not especially satisfied with the painting, which indeed did nothing to exalt the actress's social status. On the contrary, her dreamy gaze directed at the viewer seems to bring her closer, as if seeking a more direct contact with the person observing her.

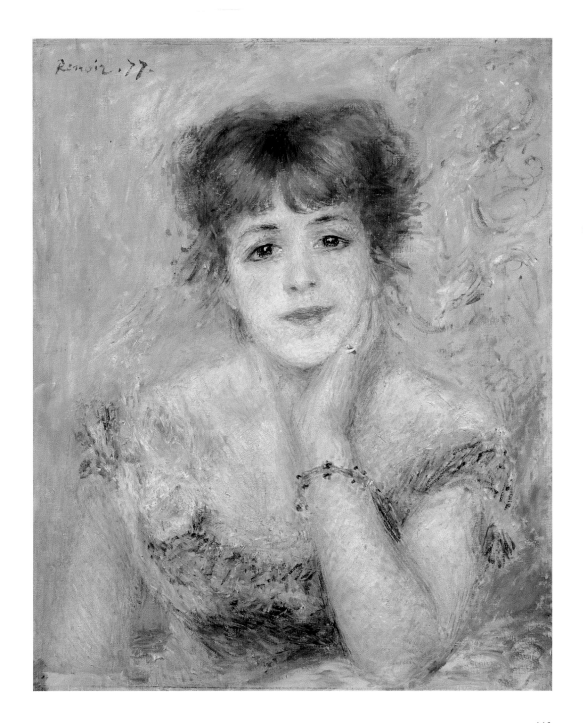

113

Portrait of the Actress Jeanne Samary

1878
Oil on canvas, 173 × 103 cm
St. Petersburg, The State
Hermitage Museum

Eager to appease the critics and the actress, who was unhappy with *La rêverie* in 1877, at the Salon of 1879, Renoir presented his most ambitious portrait of Jeanne, with her standing, dressed in a ball gown. Unfortunately, the painting was not well placed at the Salon (it was hung too high on the wall), causing it to virtually escape critical attention, unlike the portrait of Sarah Bernhardt painted by Bastien-Lepage, displayed centrally in another room, which met with great success. As a result, the actress refused to buy the painting. It remained in Renoir's studio until the art dealer Durand-Ruel bought it eight years later.

It is said that, in observing the work, Madame Charpentier (of whom Renoir also exhibited a portrait which received a better placement thanks to the model's social status) wryly noted the actress's greater corpulence in real life compared to the portrait. Indeed, a comparison of photographs of Samary—who had a physical constitution closer to a Nana than to a Marguerite Gautier—makes it clear that Renoir beautified the model somewhat, giving her fine and gentle features, softening the coarseness of the starlet.

This painting's figuration is seen echoed in the portrait of Isabella Stewart Gardner by the American painter John Singer Sargent, who seems to have adopted Renoir's composition, the slightly eager attitude of the woman who nears the observer to empathize both her sophisticated glamour and the extroverted character of Stewart Gardner, an American collector.

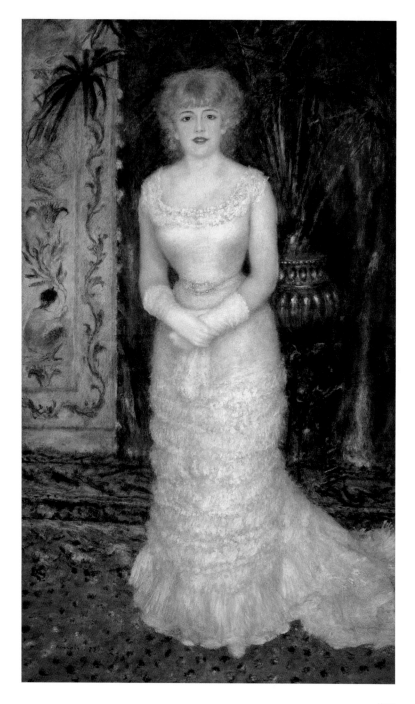

Portrait of Margot

1878
Oil on canvas, 46 × 38 cm
Paris, Musée d'Orsay

This painting portrays Renoir's friend and model, Margot (Marguerite Legrand), who appears in many of his paintings in the 1870s (e.g., *La liseuse*).

This painting came from the collection of the doctor Paul Gachet (and was donated to the Louvre in 1951 by Gachet's children), an early collector of impressionist work. Dr. Gachet was painted several times by Vincent van Gogh. According to Gachet, Renoir paid for the medical treatment of the young woman with this painting.

This work is one of the many examples of feminine beauty that Renoir captures with a sense of immediacy. He sketches the woman's features with just a few touches of color, displaying particular deftness in rendering the materials of the white scarf, her hair and bright blond braids, and her hat covered in soft fur. His brushwork is fast and fluid. The painting does not cover the entire canvas, which is left exposed. The painter is most interested in suggesting a contemplative face, struck full on by light, reproducing an image that instantly seduced him, and seducing the viewer in turn through simple, yet virtuoso painting methods.

The painting's brief and contrasted style, the large black surfaces around her face, her hairstyle and her scarf are again reminiscent of Manet's technique, the undisputed authority of the impressionist group who continued to be a model for the young painters even though he did not take part in their exhibitions.

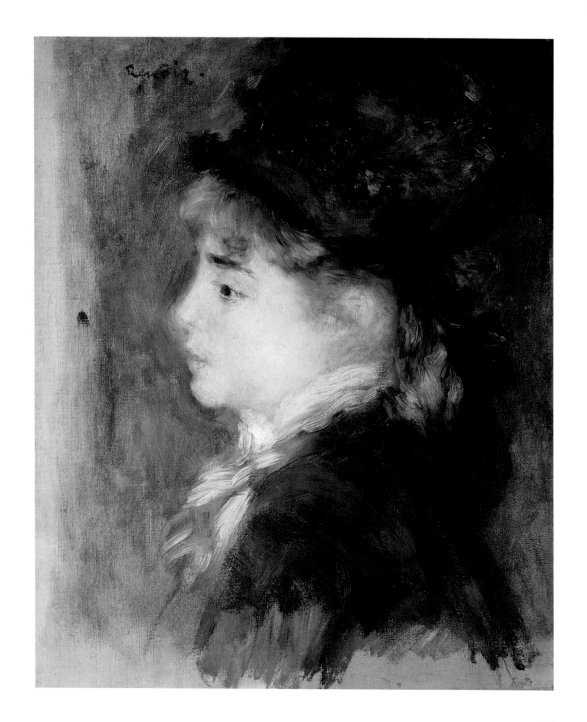

117

Portrait of Alphonsine Fournaise

1879
Oil on canvas, 71 × 92 cm
Paris, Musée d'Orsay

Renoir painted the portrait of Alphonsine, daughter of Alphonse Fournaise, a restaurant owner on the island of Chatou, on the same terrace of the restaurant where he would paint *Luncheon of the Boating Party* (1880–1882) the next year. The girl's placid, care-free features can be recognized in many paintings of this time, including *Young Woman in Blue* (1879–1882), *Girl with a Fan* (1880), and *Smiling Young Girl* (1880).

A comparison of this portrait with others of Alphosine provides an excellent example of the painter's sensibility to light. There seems to be no material that does not change its appearance depending on the intensity of light to which it is exposed. In this portrait, the girl's hair appears an imprecise color between light brown and red, while in other paintings, such as *Girl with a Fan*, it appears much darker.

Once again, Renoir shows scant interest in giving corporeal consistency to the forms, concentrating instead on the delicate color passages. The lower part of Alphosine's dress seems to blend into the tablecloth. Even the figure of the woman would seem to fuse with the background if not for the horizontal axis of the rail, which clearly separates the foreground from the landscape in the background. The landscape passage itself—the railway bridge that Renoir painted several times is seen in the background—is an excellent example of his hazy painting style. The viewer is presented with the brushwork's consistency and form, which become the focus of the work.

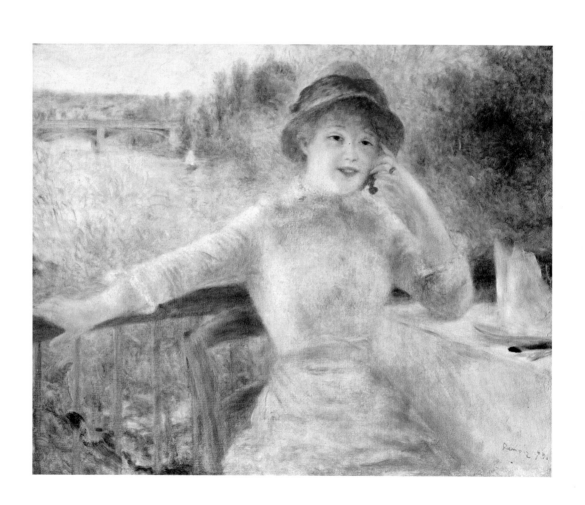

The Luncheon at the Riverbank

c. 1879
Oil on canvas, 55 × 66 cm
Chicago, The Art Institute
of Chicago

This painting may be considered an early version of the large painting that Renoir began in the summer of 1880, *Luncheon of the Boating Party*. In all likelihood, it was painted at Chatou or during a trip to Nogent-sur-Marne mentioned in a letter to his friend Murer.

We see three people, two men and a woman sitting at a table on a terrace from which the lake and some moving canoes can be seen. The figure to the left is believed to be M. de Lauradour, a painter of a friend who posed for him several times. While the men are busy relaxing from the exertion of a canoe trip, as we can infer from their poses and their athletic clothing of white rowing shirts, the woman's figure seems composed and self-contained. It is unclear whether she is looking at the man to her left, the presumed M. de Lauradour, or toward the lake, contemplating the boats.

The arbor creates a kind of perspective box in which the scene's figures are enclosed. Outside light penetrates through its wooden grid and the tangle of climbing plants, softening and diffusing in the space. These were Renoir's favorite light conditions in these years. Light that absorbs surrounding colors and reflects them in the painting's different parts, creating unusual color shadings, quite different from the colorful restaurant but in absolute accord with physical laws.

The opening in the arbor, the only element in the painting's center that does not take part of the unusual perspective construction, gives the viewer a comparison between two light situations, the interior light with a gentle and color-dense light and the exterior light, which is bright to the point of blinding. Certain iconographic and compositional similarities have been noted between this painting and a newspaper illustration, which suggests that Renoir was moving away from conventional Salon subjects.

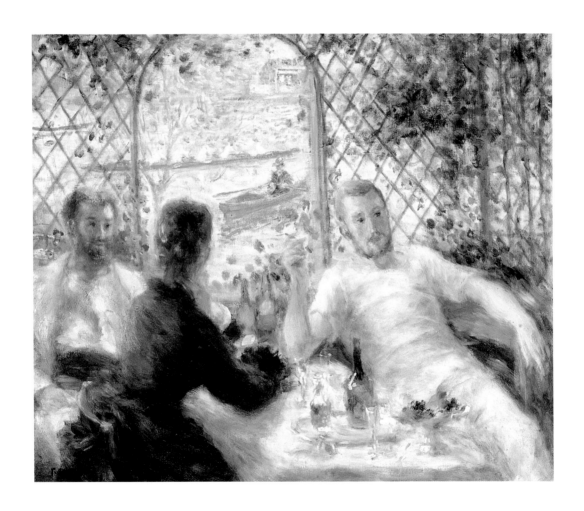

Luncheon of the Boating Party

1880–1882
Oil on canvas, 129.5 × 17.25 cm
Washington D.C., The Phillips
Collection

This painting is one of the ambitious large *en plein air* composi-
tions that Renoir worked on in the 1880s. Renoir began working
on *Luncheon of the Boating Party* in the summer of 1880, one of his
last "Impressionist" paintings. We can discern in it a break with his
previous works. The figures take on a more classical solidity and
greater attention is paid to the color balance among the painting's parts.

The composition is set in Fournaise's restaurant, which was a
popular gathering place for boaters who practiced on the Seine. In
the painting, we can recognize Aline Charigot, the painter's wife, in
the woman with the little dog, the beautiful Alphonsine Fournaise
leaning on the railing, Paul Lhote with the top hot, Lestringuez
bending over a friend who might be Georges Rivière, and Ellen
Andrée in the girl at whom Lestringuez is looking.

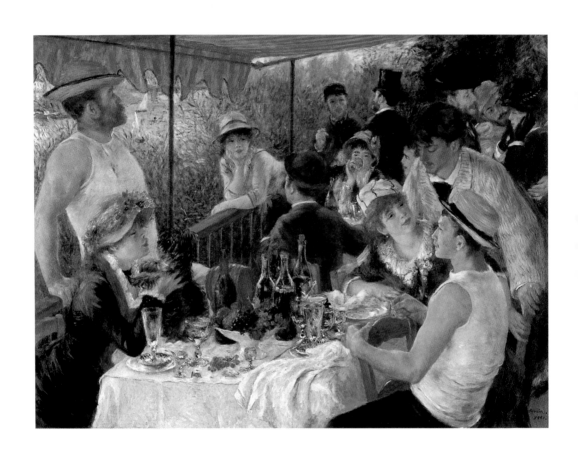

Girl with a Fan

1880
Oil on canvas, 65 × 50 cm
St. Petersburg, The State
Hermitage Museum

This painting portrays Alphonsine Fournaise, this time in unequivocal homage to Goya, Velázquez, and the fine tradition of Spanish painting. The girl is wearing a light purple dress and is painted in a frontal pose sitting in a red armchair. Her gaze is directed toward the outside edge of the painting as if shyly seeking approval from an imagined viewer.

A letter that Renoir wrote to the art dealer Paul Durand-Ruel (dated October 1885) tells us that despite the apparent spontaneity that this work shares with many of his paintings, it was born of long experiments. The three primary colors dominate the color range; red in the chair; yellow in the wall in the background, and the blue of the fabric that covers the girl's chest. The other components—the fan, Alphonsine's dress and hair—seem to absorb the three primary colors, according to the intensity of light. Renoir proves his skill here in creating a work full of fascination using but few means.

The painting was shown at the seventh impressionist group exhibition (1882) in which Renoir hesitated to be involved after having skipped the group's previous three shows. Having wearied of his friends' pursuits, so scantly rewarded with success, in 1870 Renoir had already started sending paintings to the Salon again, which some of his impressionist friends saw as a betrayal of their ideals. Renoir felt the need for approval from the public and saw the Salon as a test that artists could not avoid.

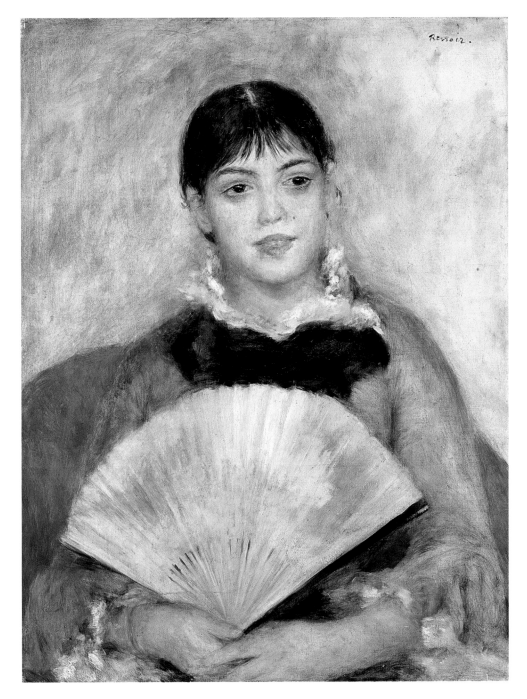

Girls in Black

c. 1881
Oil on canvas, 80 × 65 cm
Moscow, The Pushkin State
Museum of Fine Arts

This work is variously dated, either 1876—when Renoir painted famous canvases such as *Le Moulin de la Galette* and *La balançoire*—or 1881, a year before his trip to Algeria and Italy. The latter date seems more probable given the models' fuller, more linear form and the complex overall composition, filled with technical variations.

The year 1881 was a time of transition for Renoir. Unhappy with his recent work, he was rethinking his way of making art, alternating between reconnecting with masters like Raphael and Ingres and trying out new personal approaches and forms with a fresh sensibility.

Space in this painting seems to be cancelled out by the flatness of the painting material, left in a sketched state with uncommonly intense refractions of light. The lively atmosphere of a Parisian restaurant, filled with movement, is seen in the background alluded to with very rapid brushstrokes, while to the right on the corner of the table, Renoir gives the viewers a small still life of great painterly fineness.

The figures of the two women, who are not conversing and do not communicate with one another visually, are handled differently from one another. Strong applications of the palette knife delineate the body of the girl on the right; more fluid and studied brushstrokes describe the soft and shapely forms of the girl on the left, whose contemplative gaze could be directed at us or could be lost in her own thoughts. The painterly handling of the figure on the left, especially the delineated form of her face, makes it clear that hers is a stable presence unlike that of her friend's who seems to come into the viewer's gaze for just the moment, on the verge of disappearing again.

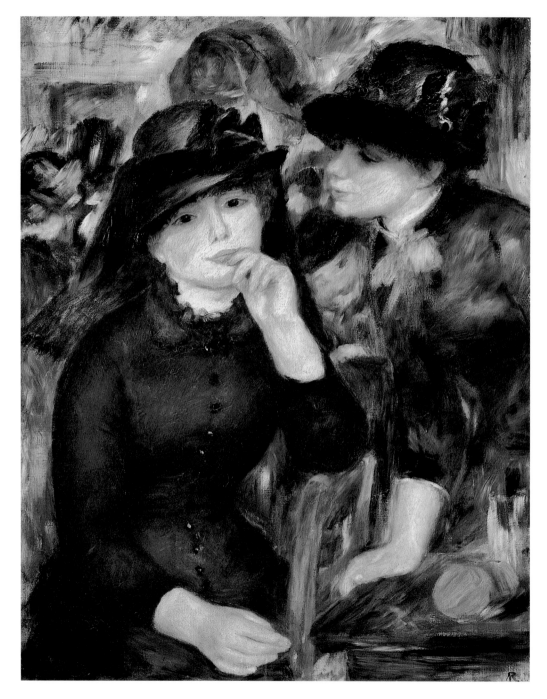

On the Terrace

1881
Oil on canvas, 100 × 80 cm
Chicago, The Art Institute
of Chicago

This painting was bought by the art dealer Paul Durand-Ruel on July 7, 1881. In all likelihood, it was painted on the same terrace of the restaurant on the island of Chatou on which Renoir also painted *Portrait of Alphonsine Fournaise* and *Le déjeuner des canotiers* (1880–1882).

The young woman seems to be the actress Darlot of the Comédie Française, and the three-year-old girl may be her child. Beyond the very high quality of the painting's execution (typical of Renoir's portrait work during these years), the artist reveals a sensitivity to portraying the state of mind of young women, who were often in front of his easel. Renoir deftly captures the curious and tenderly shy expression of the child and the typical gesture of a child drawing close to her mother.

During this period, Renoir had been introduced into the intellectual milieu through Madame Charpentier's parlor and achieved a certain level of economic stability, working on official portrait painting and canvases portraying the lives and aspirations of the upper classes. He could now afford to take trips, seeking new sources of inspiration for his paintings. Returning from a trip in Algeria, he stopped at Chatou, where he met Aline Charigot (who became his wife in 1890) and painted this and three other paintings in his excitement at rediscovering the beauty of French nature and women. From Chatou he wrote Duret, who had invited him to take a trip to England, that he had no need to go because he was "grappling with flowering trees, with women and with children and I do not wish to see anything else."

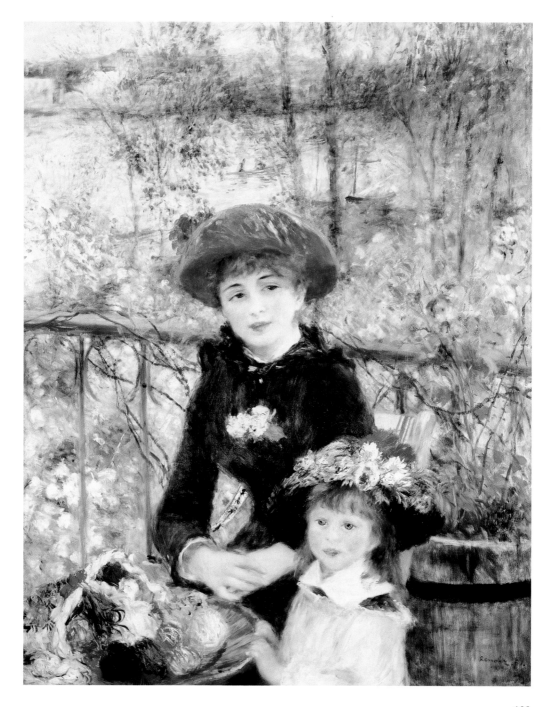

Dance in the Country

1883

Oil on canvas, 180 × 90 cm

Paris, Musée d'Orsay

In 1882, the art dealer Paul Durand-Ruel commissioned two large paintings from Renoir on the subject of dances in the city and in the country. A third painting, *Dance in Bougival* (1883), of slightly larger dimensions, with more defined figures, was added to these masterpieces. These were the last works that Renoir dedicated to the city and rural amusements of Parisians.

These paintings and their massive dimensions—the figures are life-size and take up the entire canvas, leaving little space for the background—are impressive for what has been termed the "statuesque grandeur" of the protagonists of *la vie moderne*. The dominance of these figures over the landscape is unquestionably a result of Renoir's trip to Italy where he was impressed by the plastically defined forms of Roman art and Raphael's classic linearity. Now, instead of evoking an atmosphere with its lights and characteristic colors like in *Le Moulin de la Galette* (1876), Renoir seems more interested in the definition of the human (especially female) figure on an undefined background (he painted many bathers in these years). Paul Auguste Lothe, who also appeared in the other two paintings on a similar subject, posed for this painting while the woman—radiant and seemingly extroverted—is the future Madame Renoir, Aline Charigot. Renoir imbued her with an expressive pose clearly to give an idyllic image of country life where spontaneous and natural manners prevail over the conventions that govern social relationships in the city.

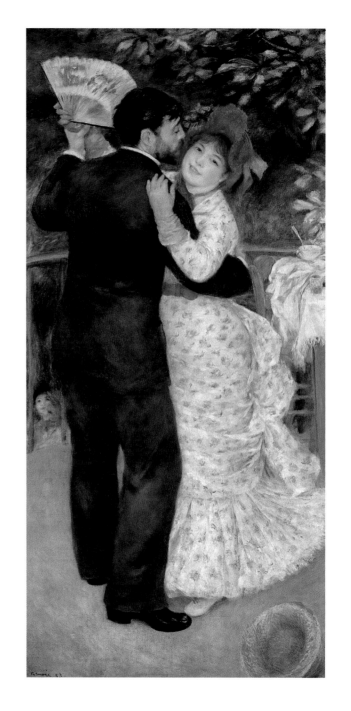

Dance in the City

1883
Oil on canvas, 180 × 90 cm
Paris, Musée d'Orsay

The male figure who poses for Renoir in the three paintings portraying dances in the country, city, and Bougival is his friend Paul Auguste Lothe. Here his arms are around Suzanne Valadon, who was a popular figure in Parisian art life. After an early debut as a circus trapeze artist, at age fifteen Suzanne was forced to end her circus career because of an accident and undertake a new career in artist studios, first as a model—she posed for Renoir, Toulouse-Lautrec, and Puvis de Chavannes, with all of whom she became lovers—and then as a painter. She was seventeen when she posed for this painting and expecting a son, who would become the painter Maurice Utrillo.

Suzanne remembered Renoir's passion for hats and how he went with her to the dressmaker and carefully chose her clothes for the two paintings (Suzanne also posed for *Dance at Bougival*). This painting is a fine example of the great care that Renoir took in composing his canvases, filled with traditional elements (taken from sixteenth- and seventeenth-century portrait painting) such as the marble half column seen in the background.

Seeking the formal elegance inherent in high society Parisian balls, Renoir gives his models contained, measured poses, quite different from the casual, dynamic setup of *Dance at Bougival* (1883) and *Dance in the Country* (1883). Despite this apparent rigidity, Renoir gives the viewer some extraordinary details, such as the dancer's evening gown: pearl white with rose and blue shadings.

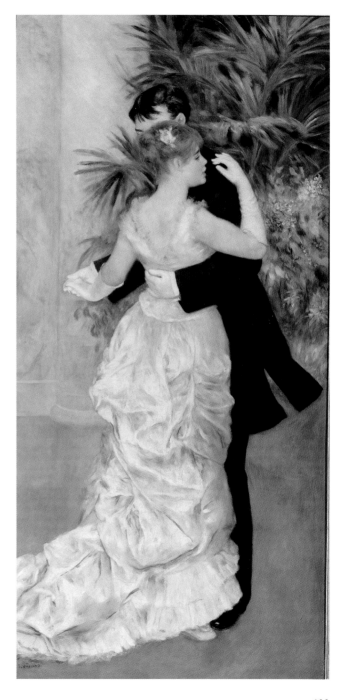

Nude amid Landscape

1883
Oil on canvas, 65 × 55 cm
Paris, Musée de l'Orangerie

When Renoir painted this work, he was in the midst of a funda-mental evolution in his painting that would revolutionize his entire artistic output. His travels in Italy, in pursuit of new sources of inspiration—now in museums rather than nature—provided him with a new figurative legacy from which to draw after abandoning *en plein air* painting, and more importantly, a new stylistic direction. The primary purpose of his travels was to see the works of Raphael. In Rome, he was impressed by the frescoes at Villa Farnesina, writing about them to Durand-Ruel: "I went to see Raphael in Rome. It's a beauty. I should have seen it earlier. It is full of learning and wisdom." He was brought back to memories of his early visits to the Louvre where he admired Ingres, a nineteenth-century follower of Raphael. Ingres became the model for his new paintings, which were carefully executed in the studio. The anatomical deformations that had once been criticized in Ingres—a modern sign of linear freedom—now cropped up in Renoir, intended to encompass and amplify the plastic effect. In defining different points of view on his model, Renoir seems to walk around her, wishing to depict her three-dimensionality, maxi-mize her physical presence, and render her an icon of femininity.

Renoir's entire body of work is an homage to feminine beauty. In every stage of his development as a painter, from his beginnings decorating porcelain (on which he executed highly elaborate nudes), to the period influenced by Courbet's thick painting, to his impres-sionist experiments—in which busts of women were set in nature and showered with light reflections—to his *aigre* period (in which he sought to define a more plastic form) through his last years in which he equated roses with feminine skin, resolving the composi-tion in uniform tones and with soft brushstrokes.

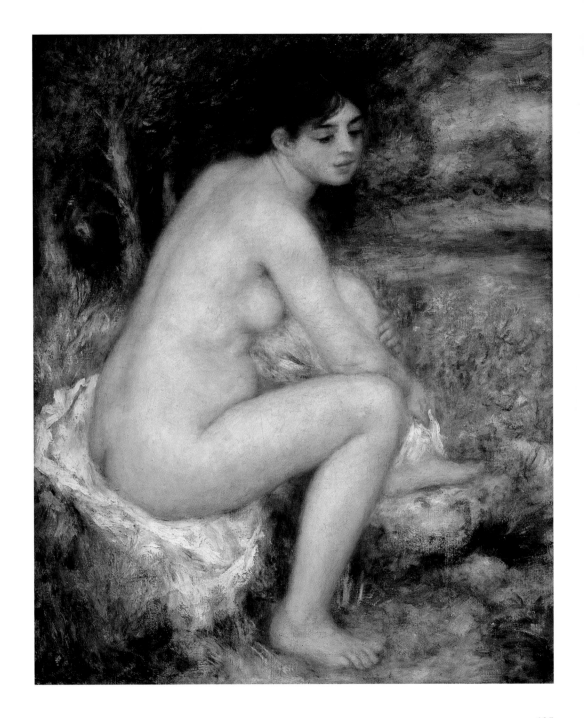

Two Young Girls at the Piano

1892
Oil on canvas, 116 x 90 cm
Paris, Musée d'Orsay

This painting was bought by Henri Roujon at Renoir's individual show held that year at Paul Durand-Ruel's gallery. Encouraged by Stéphane Mallarmé, Roujon planned to form a permanent collection of living artists at the Palais du Luxembourg. At this point, Renoir was obviously considered one of the best-known French artists of the day.

In the early 1890s, Renoir spent a great deal of time with Berthe Morisot and her husband Eugène Manet (brother to the painter Édouard Manet), visiting them in their country home in Mézy and in Paris. Their daughter, Julie, modeled for him for a few paintings in which he abandoned the severely linear style of the previous decade and returned to the soft color harmonies that he had learned from impressionism.

Many of Renoir's paintings from this period depict young girls absorbed in domestic activities, playing games, reading, or practicing their instruments. In this painting Renoir lingered on the description of certain details in the home in which the girls are practicing, such as the small paintings in the background, the curtain, the vase of flowers on the right. The delightful absorption in studying music as a subject seems to echo the contemporary work of his friend Berthe Morisot. Yellow, orange, and red dominate the painting. The blonde girl sitting in the foreground is the scene's focal point. The painter's attention lingers on the highly delicate color passages on her hair, ribbon, and dress. Her right hand shows great formal elegance as it caresses the piano keys.

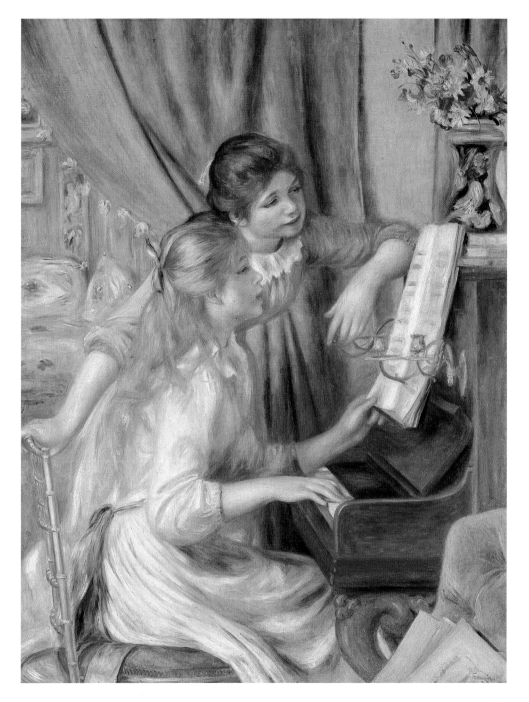

Portrait of Stéphane Mallarmé

1892
Oil on canvas
Versailles, Musée National
des Châteaux

The portrait of the poet Stéphane Mallarmé, the godfather of Symbolism, a good friend of Renoir's and the impressionist painters (for which Victor Hugo called him "my dear impressionist poet"), is not among Renoir's most successful portraits. Perhaps inhibited by his close relationship with the poet, Renoir depicted his friend's face as a kind of sculpted mask that does not reflect the interior life of the person portrayed. The result does not approach the level of the portrait that Manet painted in 1876 in which the poet is captured in a seemingly spontaneous pose while sitting on a sofa with a lit cigar in his right hand.

At that time Mallarmé formed a critical fraternity with the impressionist group, which, in his personal view, was lead by Manet. The same year the portrait was painted he wrote an article about the impressionists published in the London publication *Art Monthly Review*. The article tries to explain the specific techniques of the Impressionist language to the English public, placing painters such as Renoir, Pissarro, Sisley, and Monet in direct correlation to Édouard Manet. Mallarmé wrote, "As no artist has a color on his palette that corresponds to the open sky, the desired effect can only be obtained with the lightness or heaviness of touch or with the modulation of the tone. Now Manet and his school use simple, fresh colors or spread them lightly and their effects seem to be achieved in a single take, as omnipresent light infuses and enlivens everything [...]. What Impressionism is able to preserve is not the material fragment that already existed, superior to any representation of it, but the delight of having recreated nature bit by bit."

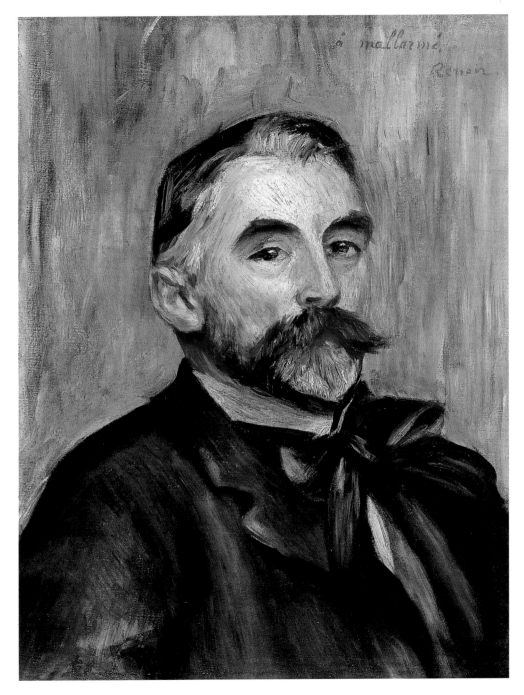

139

Gabrielle and Jean

c. 1895
Oil on canvas, 65 × 54 cm
Paris, Musée de l'Orangerie

In the 1890s and early twentieth century, many of Renoir's paintings were dedicated to family scenes in which his children were the subjects, often accompanied by Gabrielle (his wife's cousin, who came into the household in 1894 as a governess to his children and would be his favorite model for the last twenty years of his career). In works such as *Gabrielle, Jean and a Little Girl* (1895), *The Artist's Family* (1896), *Baby's Luncheon* (1904), and *The Writing Lesson* (1906), Renoir portrays the maternal figure of the girl playing with the children with frank admiration and dignity. The young Jean playing with Gabrielle is portrayed with great sensitivity. Jean, the future film director, would leave us invaluable memoirs about his father, helpful for reconstructing the painter's career and life, especially in his old age. Despite his deteriorated health, Renoir experienced a second youth, surrounded by his children, Gabrielle and the Mediterranean scenery of Cagnes-sur-Mer.

Areas of particular painterly fineness include the child's head, his golden hair reflecting the rays of light with subtle color passages, his rosy skin and cheeks, which convey a sense of vibrant cheer. Dominant colors include the blue of Gabrielle's dress and the white of Jean's clothes. Renoir uses these color contrasts to create clearly identifiable planes—here again the background is barely suggested—without using a linear preparation that would diminish the freshness of his painterly verve.

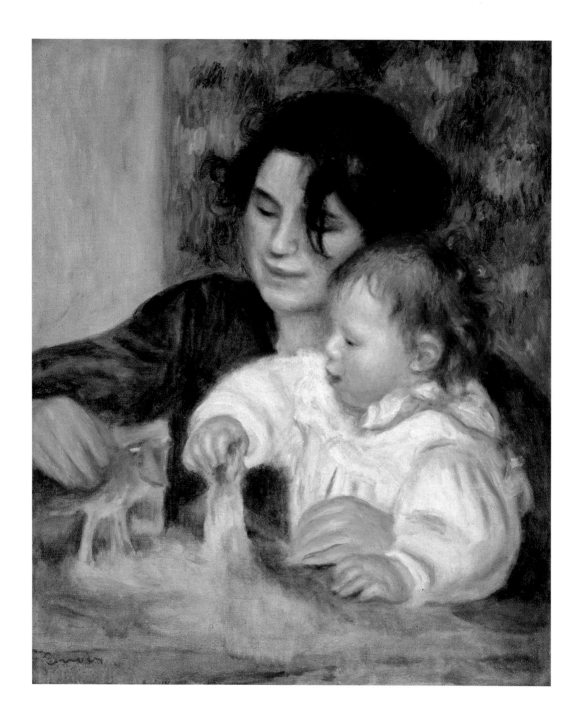

Yvonne and Christine Lerolle at the Piano

1897
Oil on canvas, 73 × 92 cm
Paris, Musée de l'Orangerie

Here Renoir portrays a dialogue between two women of the Parisian bourgeoisie practicing the piano, a subject with which he had great success in such works as *Two Girls at the Piano* (1892), shown at his individual show at Durand-Ruel's gallery the same year and bought for the Palais du Luxembourg's contemporary art collection.

Once again, the painter lingers on the details of the family environment, faithfully rendering the private, yet inviting feeling of the Lerolle home. On the wall in the background we see some works by Edgar Degas, including *Gentlemen Jockeys before the Start* (c. 1862) and a group of ballerinas (1873–1878), apparently collected by the home's owner. Renoir's painting here is measured. The viewer's eye is drawn in by the white of the woman's dress in the foreground. Yet, compared to *Jeunes Filles au Piano* (1892), the painting is restrained in its luminosity.

The image's iconography is rooted in similar scenes by seventeenth-century Dutch painters, such as the serenity of paintings by Vermeer, which greatly impressed Renoir on his trip to The Hague taken that same year. The domestic theme is on the other hand characteristic of the nineteenth century. In an ever-expanding city like Paris, the home was taking on an increasing value as a place of refuge from the noisy hubbub of the modern metropolis. These subjects of pleasant family idylls were very popular with bourgeois patrons, who liked Renoir's optimist subjects and style. From the 1880s on they regularly commissioned portraits from him.

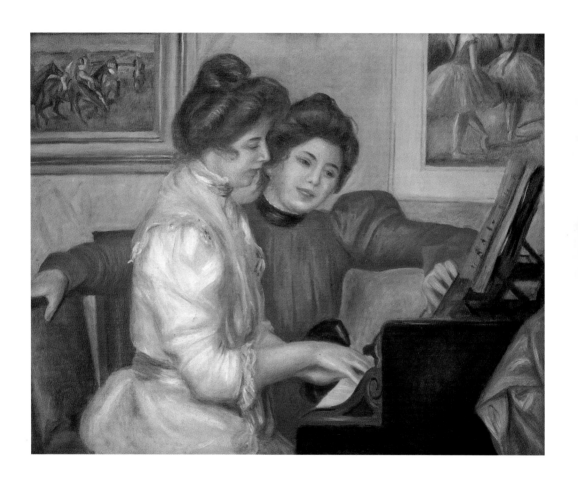

Strawberries

1908
Oil on canvas, 23 × 39 cm
Bordeaux, Musée
des Beaux-Arts

Given its total lack of literary content, still life was a natural subject for the formal experimentation of impressionists. Fine examples are found in the calibrated compositions by Henri Fantin-Latour (a friend of Renoir's from the Gleyre studio years) who continued to exhibit at the Salon, though he stayed close to the Impressionist group. Then there was Édouard Manet, who proved his skill many times over in capturing color vibrations and the sensual allure of the flowers, fruits, and vegetables he painted.

Since Renoir's earliest years as a porcelain decorator, he displayed considerable mastery and technical skill in still lifes and flowers. In his "Impressionist" period, he largely abandoned these subjects in favor of wider views of modern life and portraits. In the 1890s, with his return to painting domestic interiors, he also again ventured into the still life genre. This work is one of the finest examples. Painting strawberries gave Renoir a chance to use various tones of red, the color he favored in these years for depicting children's skin, female nudes, and roses.

Portrait of Ambroise Vollard

1908
Oil on canvas, 81 × 64 cm
London, Courtauld Institute
Gallery

Ambroise Vollard was one of the foremost art dealers in Paris during the nineteenth and twentieth centuries. He started his career in the 1890s, quickly achieving considerable success with his keen business sense and his courage in presenting the public with new work.

On Pissarro's advice, Vollard organized the first individual show of Cézanne's paintings in 1895 and the year after that he obtained the exclusive right to Paul Gauguin's painting production. In the twentieth century, Vollard was one of the art dealers supportive of the formal experimentation of the cubists, as suggested by Picasso's portrait of him (1909–1910) in which his multifaceted head appears in a mosaic of innumerous geometric fragments.

Vollard and Renoir first met in 1894. In 1918 the art dealer published a biography of Renoir, which was later contested by a friend of Renoir's, who accused him of reporting completely invented anecdotes and conversations.

In contrast to another portrait in which Vollard is dressed as a bullfighter (1917), Renoir's rendering is austerely composed to highlight the Parisian art dealer's professionalism and fine taste. The painting's iconographic type fits with sixteenth- and seventeenth-century portrait painting with such poses as Lorenzo Lotto or Bronzino employed to portray collectors and patrons. In this painting, Vollard is studying a small statue by Aristide Maillol, a sculptor and friend of Maurice Denis and the Nabis. Renoir seemed very interested in the work of Maillol, with whom he shared a love for the voluminous, soft forms of women's bodies. In fact, it was a student of Maillol's, Richard Guino, who aided Renoir in his experiments with sculpture, brought into his studio through Vollard's mediation.

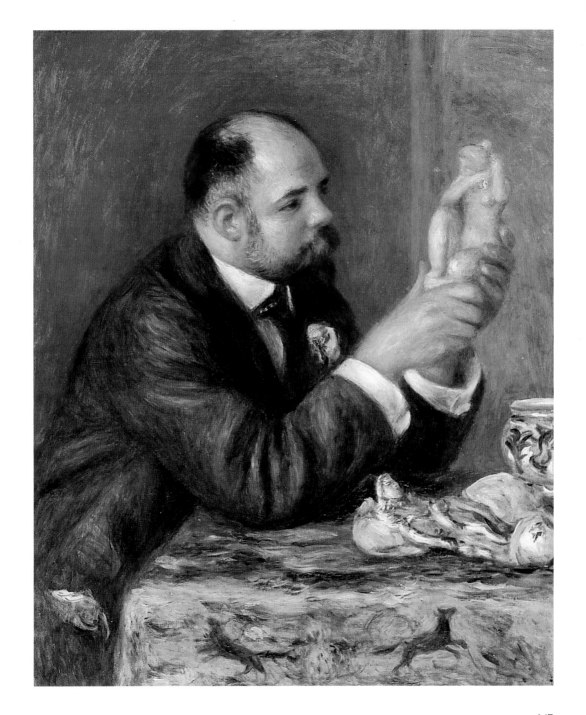

147

Reclining Woman Seen from the Back

1909
Oil on canvas, 41 × 52 cm
Paris, Musée d'Orsay

Renoir painted this canvas after completing the renovation of Les Collettes, his property in Cagnes-sur-Mer. At the time, he was working on a series of decorative panels for Maurice Gangnat's home depicting dancers with tambourines and some monumental paintings with caryatids, which would decorate the painter's own studio.

In contrast to the decorative panels, which have a strong monumental character, the other works he did in this year, mainly still lifes and nudes like this one, were intimately lyrical.

This painting echoes a work by Velázquez (*Venus Before Her Mirror*, painted between 1644 and 1648), who was much admired by Manet and the group of young painters who followed in his footsteps throughout the 1860s. The woman's body is rendered with an elegant, supple line covering the painting's entire breadth. Light reflects off the woman's hips and back, delicately modeling her body. The vibrant background gives the impression of an exquisite arabesque interrupted only by white *taches* on the sheet and pillow. A new sense of formal freedom guides the brushstroke, which is rapid and modulates the nude with delicacy, describing the weight of the curtain in a mixture of yellows and reds. It is color that constructs the painting, rendering the portrayal immediate and vivid. The line defined by contour, typical of his Ingres-influenced period, is absent.

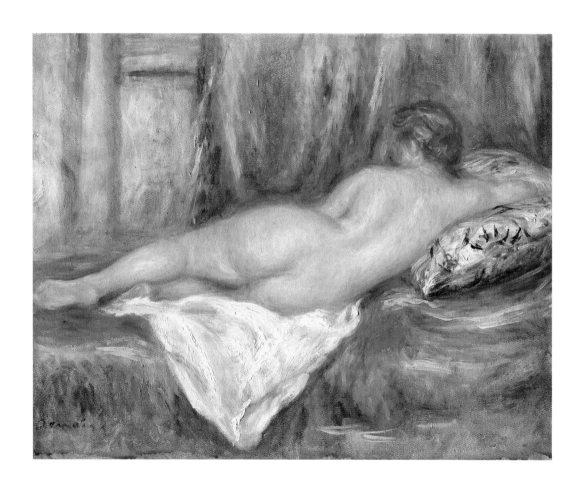

The Clown

1909
Oil on canvas, 120 × 77 cm
Paris, Musée de l'Orangerie

Following the portrait of his second-born son, Jean, dressed as Pierrot (1902), Renoir worked on this portrait of his younger son, Claude (nicknamed Coco), who was born in August of 1901. The scene has nothing of the spontaneous family episode, being carefully studied and referencing official portrait painting by artists such as Veronese, Velázquez, and Van Dyck. Its primary reference is to *Pierrot* by Watteau, of which it is virtually a quotation. The figure in Watteau's painting has a melancholy air, an emblem of the misunderstood artist, the spiritual cousin of Picasso's acrobats and harlequins. Renoir's *Pierrot* has none of this sorrow. The painter is most interested in the costume and the painterly rendering of the red. The image's austere composition befits a portrait of an aristocrat (the column in the background usually symbolizes those who exercise worldly power), while the model is the sweet figure of a child dressed as a clown. It is unclear if Renoir intends to pay homage or to parody official portrait painting of which he himself had produced fine examples, if in different forms.

In Claude Renoir's memoirs (*Renoir, My Father*, Paris, 1948), he recounted the work's origins, a trying experience for him because of the discomfort of the tights. After much insistence and bribery from his mother, who promised him a wooden model train and a box of paints, "I decided to put on the cotton tights for a little while. My father—holding in the fury that seemed ready to explode at any moment—managed to finish the painting despite my constant contorting to scratch myself."

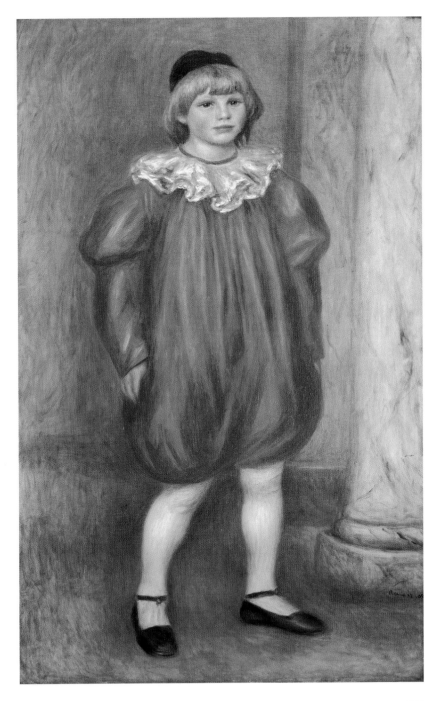

La toilette
(Woman Combing Her Hair)

1910
Oil on canvas, 55 × 46 cm
Paris, Musée d'Orsay

This painting is yet another of the countless examples of Renoir's life-long fascination with the intimate feminine world. The painting, likely done in Cagnes-sur-Mer, depicts a woman in a white undershirt combing her hair during her morning *toilette*.

The year 1910 was full of new successes as well as serious health problems for Renoir. With the help of his friend Georges Rivière, the French edition of Cennino Cennini's treatise on painting, for which Renoir wrote the introduction, was published. Renoir continued to paint portraits requested by the upper echelons of Europe, this time not refusing the commission from the German industrialist Thurneyssen, who summoned him to Munich to paint the portrait of his wife and child. After his return to Les Collettes he was struck by an attack of rheumatism that completely paralyzed his legs. His partial immobility bound him to a wheelchair from this point on.

Max-Pol Fouchet wrote that the woman in Renoir's later work was the "the giantess bearer of life, the progenitor, resembling pagan reproduction divinities, mothers of fertility. The red of their flesh is the red of blood and fire." Their gestures are the eternal, immutable gestures of maternity, of the Anadyomene Venus, Venus grooming herself, the Source, the inspiring force of the entire span of the history of art and bearers of an ideal message. The nude renderings of these women became rounded forms, animated by an eternal, monumental rhythm, while losing none of their plasticity (in these very years Renoir worked on translating his works into sculpture).

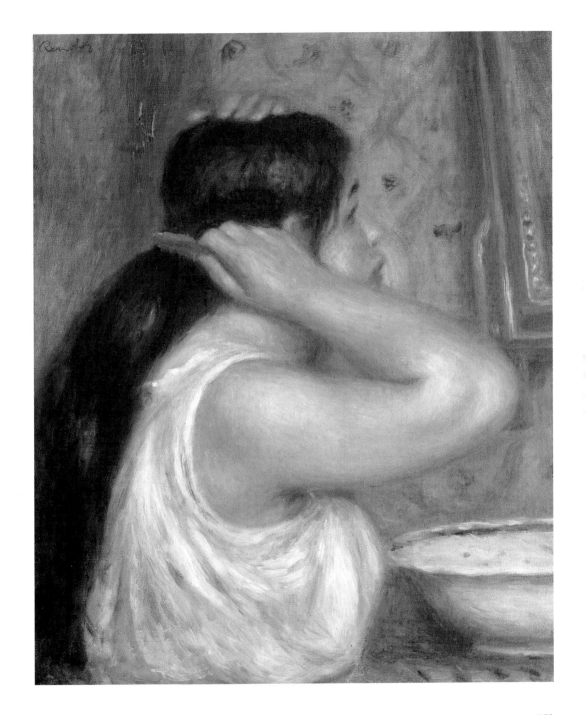

153

Roses in a Vase

1910
Oil on canvas, 29 × 33 cm
Paris, Musée d'Orsay

From 1896 on Renoir painted many studies of roses, whose fragrance and color fascinated him, as well as their allusion to feminine beauty, of which they seemed to symbolize the most intimate secrets. In one of the conversations recounted in Ambroise Vollard's biography (1918), Renoir reveals that many of the roses in his paintings began as color studies for his nudes. He seems to equate flowers with female nudes; in seeking the right tone for the skin, he almost instinctively arranged the paint in the shape of a rose, giving a concrete reason to a purely symbolic analogy.

It is a remarkable and significant coincidence that in these very years Monet was busy in his garden in Giverny painting his water lilies with a nature-worshipper's devotion while Renoir, in the Mediterranean surroundings of his home Les Colettes in Cagnes-sur-Mer, paired roses and female nudes, making use of the flower to portray what most interested him—feminine beauty. Just like the old days when they stood side by side and painted the same subjects on the shores of the Seine, achieving different results, once again the two artists captured different aspects of similar images. For one artist, painting meant abandoning himself to the inspirations of the universe; for the other, it was an opportunity to create a "humanized" nature, to give the viewer a gift of the forms that are in full harmony with the greens, blues, and pinks that surround them; and, in fact, condition their very substance by the light that these colors emanate, as in the impressionist period.

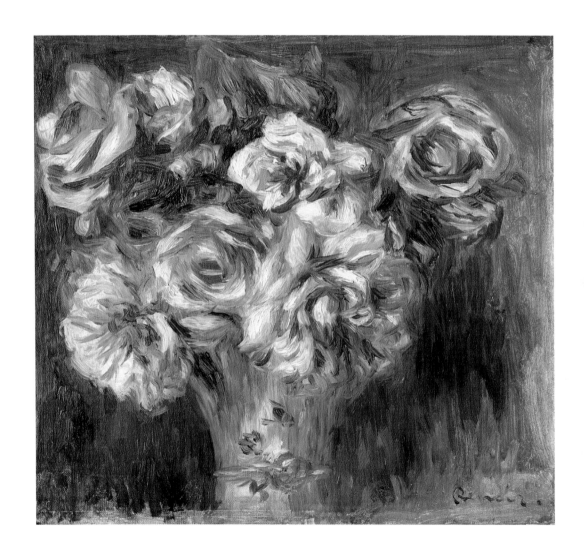

Gabrielle à la rose

1910
Oil on canvas, 82 × 166 cm
Geneva, Skira Collection

Between 1907 and about 1910, Renoir painted Gabrielle in a series of works, showing her dressed in large transparent tunics open at the breast, a rose in her hair or hand, and an undefined background that creates a timeless atmosphere. The rose symbolizes the youth of the model, Aline's cousin, who came at the age of sixteen in 1894 to help her after the birth of Renoirs' second child, Jean. Gabrielle remained with the Renoirs and became the painter's favorite model, infusing fresh youth into his life and painting. His paints became increasingly thick, spread with a freedom that was the culmination of his entire learning process, from museums, to *en plein air* experimenting, back to the studio and finally to nature, experienced and interiorized. like that of Gabrielle in her Rubenesque grandeur, still maintaining her tangible corporeality, never turned into a mere symbol. Renoir's late work, entirely dedicated to painting Gabrielle and other models' portraits (including Dédé) clearly shows that his painting and his life had converged more than ever. As Jean Renoir remembered, "Our house was a house full of women. My mother and Gabrielle and all the young girls, servants and models who moved about gave it a distinctly non-masculine tone." The old painter, worried about the future of women, considered himself in a position to make pronouncements on women's emancipation: "What they gain on one hand, they will lose on the other. […] What they gain in education, they may lose elsewhere … When women were slaves, they acted like bosses. But now that they are starting to have rights, they lose importance. When they become the same as men, then they will know true slavery."

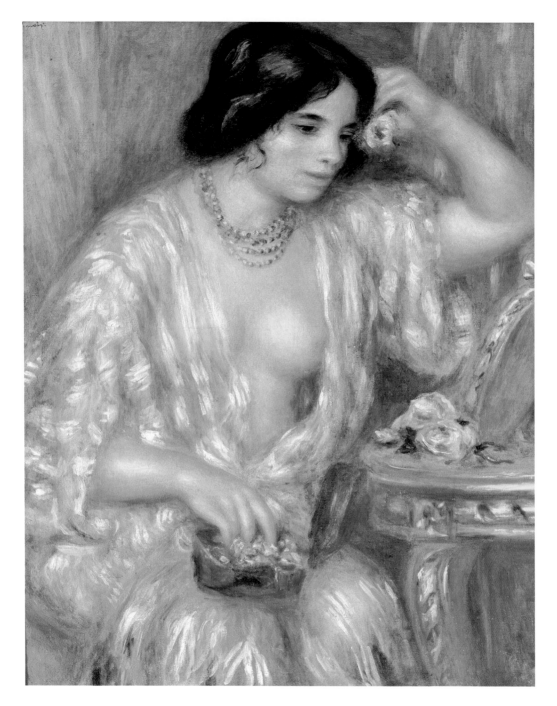

Reclining Woman

1910
Oil on canvas, 67 × 160 cm
Paris, Musée de l'Orangerie

This painting makes the viewer witness to an intimate dialogue between the painter and the model at the time of the work's execution. The model, once again Gabrielle Renard, lies in the foreground turning a direct and uninhibited gaze to the viewer. The image's iconographic predecessors include Titians' Venuses and figures such as Goya's *Maja Desnuda* in addition to Ingres's Odalisques, from which Renoir culled inspiration, particularly in his *aigre* period in the 1880s, when he rediscovered the linear tradition within his own artistic pursuits.

We have a photograph of Gabrielle posing for this painting, lying on the pillows, which shows us how Renoir rendered the woman's features rounder and softer, transcending the model before him in order to create another form that owed much to the Venuses he saw during his frequent study sessions at the Louvre. These last years of Renoir's painting were entirely dedicated to his favorite subject, the female nude, the cornerstone and ultimate testing grounds of art, past and present. He also tried his hand at molding his painted forms beyond the two-dimensional plane of the canvas with the help of a young Catalan sculptor, Richard Guino, translating his paintings into statues with full and simple forms (*Venus*

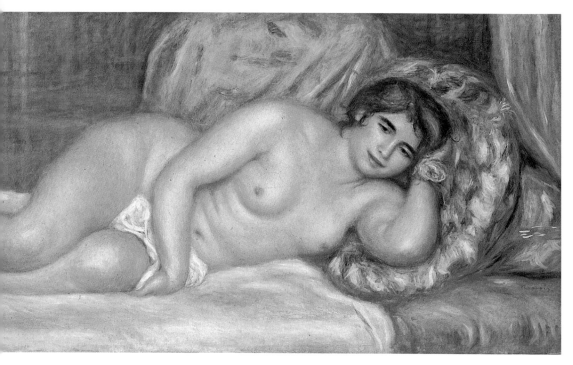

Victrix is a prime example), closely tied to Maillol's work at the time.

Renoir said at this time, *Ce que j'aime en peinture, c'est ce qui a l'air éternel* (What I love about painting is that it has a timeless feel). His debt to the past had been paid by creating an absolute image of the "eternal feminine" which absorbs and surpasses both the objective photographic model of the nude and the form passed down throughout centuries of art history.

Gabrielle with a Rose

c. 1911
Oil on canvas, 55 × 46 cm
Paris, Musée d'Orsay

Gabrielle Renard, the cousin of Aline Charigot (Renoir's wife), was the daughter of a wine grower from Essoyes. When she was sixteen years old, in 1894, Renoir brought her into the home to help his wife who was expecting their second child. For the next twenty years, Gabrielle would remain Renoir's favorite model. She would even pose, donning a Phrygian hat, for the figure of Paris in the *Judgment of Paris*, 1914.

In this painting Gabrielle is wearing a beautiful shirt open at the breast. Its transparencies are rendered with bright white brushstrokes. The background is undefined, softly melding with the forms of the woman.

Having moved passed his more linear, *aigre* phase of the 1880s, Renoir said, "I love thick, smooth, greasy painting. I love to handle a painting, running my hands over it." Indeed, the model's figure, which Renoir loved for her Rubenesque curves, is rendered in a painting of great depth. The rose emphasizes the sensuality of her body and her pale skin, alluding to her youth and setting the red tone of the painting.

Renoir's late work is often overlooked in the desire to categorize him as an impressionist painter of scenes of bourgeois *en plein air* pleasures. In reality, his impressionist phase was just one of many—and relatively short-lived at that—in his painting career, which achieved great heights during these years. It was his soft brushwork and rosy tones that artists such as Matisse would remember when they visited the elderly painter at Cagnes-sur-Mer, a new destination for pilgrimages for many young artists of the time.

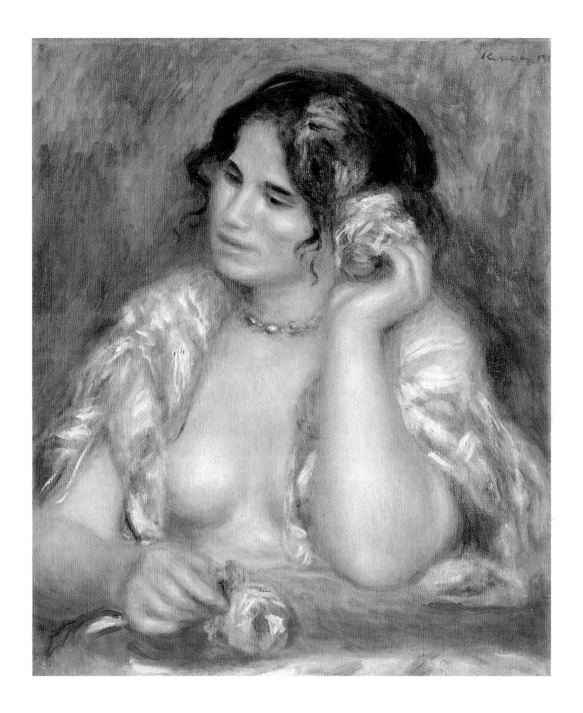

Gabrielle with Large Hat

1915–1916
Oil on canvas, 55 × 37 cm
Grenoble, Musée de Grenoble

This time Gabrielle is painted fully dressed wearing an elegant blouse and a hat adorned by a rose and a large shirt. The entire painting is executed in variations of red.

Again we see an echo of classic portrait painting in the tradition of David and Ingres, especially in Renoir's choice to structure the painting's background in two large red and yellow areas that meet above Gabrielle's head. Renoir avoids creating an impression of excessive austerity that this abstract background might convey by lightening the painted surfaces with gradations of softer colors that contribute to creating a particularly luminous effect. The viewer's eye is drawn to the flower on the edge of the hat, which stands out from the painting's surface. Here we can intuit Renoir's latent sculptural mentality (in these years he was working on statues of Venus) as he moulds the material consistency of the natural model of the rose with the dense brushstrokes.

In the last years of his life, Renoir strongly favored red, from rosy shadings of skin to deep reds of roses and strawberries. He loved to capture the flow of the forms, modulating red with fresh approaches in a wide range of gradations.

To a young painter eager to learn his method, Renoir shared, "I arrange my subject as I want it, then I go ahead and paint it, like a child. I want a red to be sonorous, to sound like a bell; if it doesn't turn out that way, I add more reds and other colors until I get it. I am no cleverer than that. I have no rules and no methods; anyone can look at my materials or watch how I paint—he will see that I have no secrets." Renoir's childlike joy in his craft, combined with his persistent aversion to theoretical and aesthetic ponderings, remain defining traits of his art. Renoir does not try to hide himself in his creations. His aim is to communicate his pleasure in life and painting as directly as possible.

Woman Leaning on Her Elbow

1917–1919
Oil on canvas, 23 × 32 cm
Paris, Musée de l'Orangerie

This painting, which was among Renoir's last works as he was now elderly and increasingly hindered by the pain of his disfiguring arthritis, gives us fine insight into his artistic process. Its composition is a triangle, formed by the woman's contours (her shoulders and elbow form two axes of it), which takes up most of the painted space.

Once again the dominant color is red, which Renoir used in these years to paint roses, the skin of women and children, and fruit. Renoir modeled the image of the woman's face as she leans on her elbow with a few thick brushstrokes. The paint becomes increasingly thick and in his later works takes on tactile qualities—almost like clay—as Renoir was paralyzed much of his body and could no throughout longer manipulate the paintbrush with the fineness seen in his best-known paintings. Beginning in 1913, encouraged by the dealer Ambroise Vollard, Renoir worked increasingly experimented with sculptural language, particularly in reliefs modeled with Richard Guino, a student of Aristide Maillol's. This painting evinces how much his sculptural works influenced his painting in his last years, and vice versa. The sculptures were in effect a sculpted translation of his paintings, a final approach sought under the Mediterranean sun of Cagnes-sur-Mer to a pursuit of solidity and synthesis going back to his Ingresque period of the early 1880s.

Portrait of Adèle Besson

1918
Oil on canvas, 41 × 36.8 cm
Besançon, Musée
des Beaux-Arts

Adèle and Georges Besson were dedicated art patrons whose collection included works by Renoir, Berthe Morisot, Maillol, Camille Claudel, Van Dongen, and Picasso. They were acquainted with Albert André, a young painter friend of Renoir's who often visited the elderly master in his refuge in Cagnes-sur-Mer.

The woman's face is portrayed on an undefined background, created with thick paint, sketched with an immediate feel. Short, thick brushwork molds the face, which strong color contrasts illuminate. Georges Rivière wrote that what made Renoir an exceptional portrait painter was his ability to shed all of the artificial props of his models' social status, whether they be a laundress or a society woman, an adult or a child. "He managed to put the person posing completely at their ease. Many remember the patience and kindness with which he won their favor," and this freedom was transferred to the painting's composition.

Renoir's late work is dominated by yellow and red hues, the colors of the sun and roses. The elderly master, surrounded by the Mediterranean scenery of Cagnes, expressed radiance in every brushstroke that he struggled to put to the canvas. Paintbrushes were tied to his hands, which had been paralyzed by arthritis. Alive only in the times he dedicated to his art, he worked on a sliding easel that minimized the need for movement and continued to paint, with the joy and ingenuousness of a child, female nudes and faces, equating the skin of the women portrayed with the color of roses and gracing his subjects with new freshness.

The Great Bathers

1918–1919
Oil on canvas, 110 × 160 cm
Paris, Musée d'Orsay

The model for this painting is Dedé, the Russian Andrée Heuchling, who would become Jean Renoir's first wife. She was one of Renoir's favorite models toward the end of his life; he portrayed her with strong Rubenesque curves. The theme of the bather was recurrent in his last years ("an indispensable form of art," Renoir said to Berthe Morisot). Renoir's women are free, uninhibited beings who fully experience their physicality.

The nudes he painted in the 1880s—with clean contours characteristic of his *aigre* period—took on a new naturalness in the following decade: the lines softened and his brushstroke became more fluid. "I look at a nude. There are a myriad of tiny tints. I must find the ones that will make the flesh on my canvas live and quiver." In this period, Renoir had fully assimilated Titian's and Rubens' fundamental lessons. He adopted a new imaginative freedom and stopped looking too strenuously at art in the museums, overcoming the conflict between the studio and *en plein air*. This last *Bathers* was Renoir's swan song. The bathers are literally immersed in nature and their shapes mix and meld in their rosy tones with trees, flowers, and water. On the verge of death, Renoir achieved a hymn to life and earthly beauty, still with a child's wonder. The bountiful shapes of the women that he painted in these years were commented on by some critics who disparaged the enormous size of the legs and arms, the softness of the flesh and the rosy color of the models' skin. Renoir answered them by explaining his intention to meld the figures with the landscape that serves as their background to create a union with earthly energies, from which femininity cannot be dissociated.

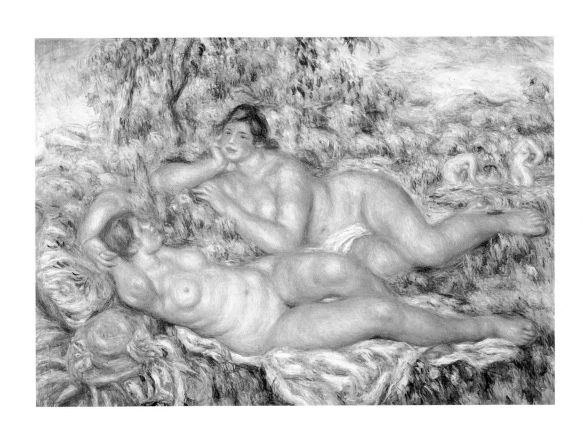

169

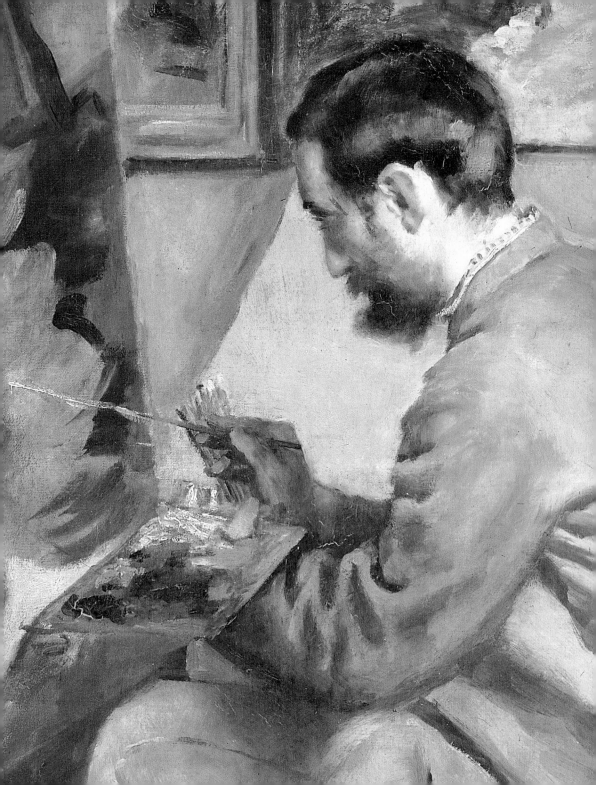

Appendix

Portrait of Bazille
(detail), 1867
Paris, Musée d'Orsay

Chronological Table

	Life of Renoir	Historical and Artistic Events
1841	Pierre-August Renoir is born in Limoges on February 25 to a tailor and a seamstress.	Frédéric Bazille, Armand Guillaumin, and Berthe Morisot are born.
1844	The family moves to Paris.	
1848	Studies at the Christian Brothers School, located near the Louvre. Renoir is a successful student, distinguishing himself in drawing and singing.	Second Republic proclaimed in France. Marx and Engels publish *The Communist Manifesto*. Gustave Caillebotte is born.
1854	Apprentice porcelain decorator at Lévy's factory. Takes classes from Callouette at the École de Dessin et d'Art Décoratifs. Befriends the painter Émile Laporte.	Urban restructuring begins in Paris following Baron Haussmann's plan.
1859	Paints subjects for the painter Gilbert, who paints sacred images.	Piedmont defeats Austria in the Second War of Independence. Seurat is born in Paris.
1860	Authorized to go to the Louvre to copy works. His models include Rubens, Fragonard, and Boucher.	Garibaldi leads the Expedition of the Thousand. The treaty of Turin cedes Nice and Savoy to France. Annexation of some Italian states to Piedmont.
1862	Leaving Gilbert, he takes classes from Gleyre at the École des Beaux-Arts; meets Monet, Sisley, and Bazille.	Manet paints *Music in the Tuileries* and meets Degas. Victor Hugo publishes *Les Miserables*.
1863		Manet exhibits *Déjeuner sur l'Herbe* at the Salon des Refusés, causing great scandal.
1864	Admitted to the Salon with *Esmeralda Dancing*. Does not move to Ville-d'Avray with his family, staying in Paris, first a guest of Sisley and then of Bazille who shares his studio with Renoir.	
1865	Paints *en plein air* in the forest of Fontainebleau with Monet, Pissarro, and Sisley. Meets Courbet and becomes involved with Lise Tréhot.	Manet exhibits *Olympia* at the Salon amidst general indignation.
1866	Paints his first important painting at Marlotte: *At the Inn of Mother Anthony*.	Manet paints *The Fifer*, Monet paints *Women in the Garden* and exhibits *Camille* (*Green Dress*) at the Salon. Mary Cassatt arrives in Paris.

	Life of Renoir	Historical and Artistic Events
1867	Rejected from the Salon for the second consecutive year, Renoir, Bazille, Pissarro and Sisley try to promote a new Salon des Refusés, without success.	At the Universal Exhibition of Paris, Manet and Courbet exhibit in individual pavilions. Émile Zola publishes *Thérèse Raquin*; Marx publishes *Das Kapital*.
1868	Meets with great success at the Salon, where he shows *Lise with Parasol*. Paints *Skaters in the Bois de Boulogne*.	Degas and Manet participate in the Salon; Degas exhibits *Eugénie Fiocre in the Ballet "La Source"*, Manet, *Portrait of Zola*.
1869	Exhibits at the Salon d'Estate. Works with Monet on the island of Croissy on the Seine; they paint the bathing resort of Grenouillère.	Opening of the Suez Canal. Manet exhibits *The Balcony* at the Salon. Gustave Flaubert publishes *A Sentimental Education*.
1870	During the Franco-Prussian war, he is enlisted and sent to Tarbes near Bordeaux.	The Franco-Prussian war breaks out. France is defeated at Sedan. Bazille dies in combat.
1872	During the summer, he paints often with Monet, who has settled in Argenteuil on the banks of the Seine.	International Peace Conference at The Hague. Monet paints *Impression, Sunrise*, shown at the first impressionist group show in 1874.
1873	He and other future impressionists set up a cooperative of artists, painters, sculptors, and engravers.	German troops retreat from France. Cézanne is Dr. Gachet's guest at Auvers-sur-Oise, where he paints *A Modern Olympia*.
1874	The cooperative holds its first exhibition in the studio of the photographer Nadar in Paris. Renoir participates with seven paintings, including the *Theatre Box*.	Manet does not participate in the first impressionist show, absenting himself from the group's subsequent shows as well. Paul Verlaine publishes *Romances sans Paroles*.
1875	He is one of the organizers of the auction at Hôtel Drouot, where works not purchased at the 1874 show are put up for sale, meeting with poor results.	Degas begins painting *Glass of Absinthe*.
1876	Exhibits fifteen works at the second show of the impressionist group. Meets the financier Cernuschi, an eminent collector and the banker Ephrussi. Paints *Le Moulin de la Galette*.	Caillebotte organizes the second impressionist show. Wagner's *Ring of the Nibelung* is shown in Bayreuth. Mallarmé publishes *L'Après-Midi d'un faun*.
1877	Participates in third impressionist show with *Le Moulin de la Galette*, *The Swing*, and another twenty pieces.	Cézanne shows with the impressionists for the last time. The first issue of the *L'impressionniste* comes out. Courbet dies in Vaud.

Life of Renoir	Historical and Artistic Events
1879 Does not participate in fourth impressionist show; admitted to Salon with *Portrait of Jeanne Samary* and *Madame Charpentier with Her Children*. Madame Charpentier is the wife of the editor of *La Via Moderne* magazine and owner of the gallery where an individual show for the artist is held. Aline Charigot enters his life.	Mary Cassatt shows with the impressionists for the first time at their fourth exhibition. Thomas Edison invents the electric lightbulb.
1880 Absent from the fifth impressionist exhibition, exhibits at the Salon with much success. His financial situation improves. Begins painting *Le Déjeuner des Canotiers*.	Fifth impressionist group show, which includes the first participation of a young Gauguin. Flaubert dies.
1881 Does not participate in the sixth impressionists show. Travels to Algeria and then Italy, where he is impressed by Raphael's frescoes and the wall paintings in Pompeii.	France occupies Tunisia. Degas shows some pastels and wax statuettes at the sixth impressionist show. Manet receives the Legion of Honor. Redon holds his first individual show at the Charpentier gallery. Pablo Picasso is born.
1882 Goes to Palermo at the beginning of the year where he meets Wagner and paints his portrait. Returns to France, stopping at Estaque, where he visits Cézanne. Some of his paintings owned by the art dealer Durand-Ruel are shown at the seventh impressionist group show.	Seventh impressionist exhibition. Cézanne is admitted to the Salon for the first and only time where Manet also exhibit *A Bar at the Folies-Bergère*. Braque is born. Gaudí begins to build the Sagrada Familia in Barcelona. Dante Gabriel Rossetti dies.
1884 Dreams of founding a new association of painters, *Société des Irrégularistes*. At Wargemont, a guest of the Bérards, he paints *Children's Afternoon at Wargemont*	The École des Beaux-Arts in Paris has a retrospective of Manet's work a year after his death. Monet shows at the third international exhibition at Georges Petit's. Seurat makes the first studies for *A Sunday on La Grande Jatte – 1884*.
1886 Absent from last impressionist group show, but has twenty-eight paintings in the impressionist show organized in New York by Durand-Ruel. Has a few works at the fifth international exhibition at Petit's gallery.	Eighth and last impressionist show. Seurat and Signac participate for the first time. Henri Rousseau exhibits at the second Salon des Indépendants. Jean Moréas publishes the "Symbolist Manifesto" in *Le Figaro*.
1887 Exhibits *The Great Bathers* at the sixth international exhibition at Petit's. Meets Stéphane Mallarmé at Berthe Morisot's house and they become friends.	

	Life of Renoir	Historical and Artistic Events
1890	Exhibits in Brussels with the Society of the Twenty and in Paris at Durand-Ruel's gallery. Marries Aline Charigot in a civil ceremony.	
1892	Successful retrospective of his work organized by Durand-Ruel. Paintings in the show include *The Theatre Box, Le Moulin de la Galette, Luncheon of the Boating Party* and *The Great Bathers*.	Secessions of Munich, Berlin, and Vienna led by Max Klinger, Max Liebermann, and Gustav Klimt, respectively.
1897	Travel abroad: London, The Hague, Bayreuth, and Dresden.	First Secession show in Vienna.
1898	Acute symptoms of severe rheumatism appear.	Cézanne begins the first of three versions of *The Great Bathers*. Moreau and Mallarmé die.
1900	Awarded the Legion of Honor.	World's Fair in Paris.
1904	Receives definitive seal of approval at the Salon d'Automne.	
1905		The Fauvist group is founded in Paris; the expressionist group Die Brücke is formed in Dresden.
1907	At auction of Charpentier collection, *Madame Charpentier and Her Children* receives the highest price of any of his paintings thus far. Buys Les Collettes estate at Cagnes-sur-Mer, where he moves the following year.	Pablo Picasso paints *Les Demoiselles d'Avignon*.
1911	Continues to paint with brush tied to his hands despite disfiguring arthritis.	Kandinsky and Marc found Der Blaue Reiter in Munich.
1914	Becomes interested in sculpture; Richard Guino physically executes about fifteen statues conceived by the artist.	World War I breaks out. Major Chagall show in Berlin.
1915	His wife Aline Charigot, with whom he had three children: Pierre, Jean and Claude, dies.	Italy enters war against Austria.
1917	Individual show at Durand-Ruel's in New York.	October Revolution in Russia. Mondrian founds De Stijl.
1919	Dies the night of December 3 after completing *The Bathers*.	The League of Nations is founded. Gropius founds the Bauhaus in Weimar.

Geographical Locations of the Paintings

France

Portrait of Adèle Besson
Oil on canvas, 41 x 36.8 cm
Besançon, Musée
des Beaux-Arts
1918

Strawberries
Oil on canvas, 23 x 39 cm
Bordeaux, Musée
des Beaux-Arts
1908

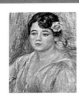

Gabrielle with Large Hat
Oil on canvas, 55 x 37 cm
Grenoble, Musée de
Grenoble
1915-1916

Portrait of William Sisley
Oil on canvas, 81 x 65 cm
Paris, Musée d'Orsay
1864

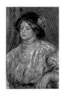

Portrait of Bazille
Oil on canvas, 106 x 74 cm
Paris, Musée d'Orsay
1867

Claude Monet Reading
Oil on canvas, 61 x 50 cm
Paris, Musée Marmottan
Monet
1872

The Seine at Argenteuil
Oil on canvas, 46 x 65 cm
Paris, Musée d'Orsay
c.1873

*Path Leading through the
High Grass*
Oil on canvas, 60 x 74 cm
Paris, Musée d'Orsay
c. 1874

Portrait of Charles Le Cœur
Oil on canvas, 42 x 30 cm
Paris, Musée d'Orsay
1874

Portrait of Claude Monet
Oil on canvas, 84 x 60 cm
Paris, Musée d'Orsay
1875

France

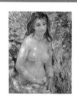

Nude in the Sun
Oil on canvas, 81 x 64 cm
Paris, Musée d'Orsay
1875

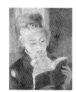

The Reader
Oil on canvas, 47 x 38 cm
Paris, Musée d'Orsay
1875-1876

Le Moulin de la Galette
Oil on canvas, 131 x 175 cm
Paris, Musée d'Orsay
1876

*La balançoire
(The Swing)*
Oil on canvas, 92 x 73 cm
Paris, Musée d'Orsay
1876

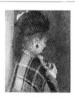

Young Woman with a Veil
Oil on canvas, 61 x 51 cm
Paris, Musée d'Orsay
c. 1876

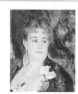

*Portrait of Madame
Charpentier*
Oil on canvas, 46 x 38 cm
Paris, Musée d'Orsay
1876-1877

Portrait of Margot
Oil on canvas, 46 x 38 cm
Paris, Musée d'Orsay
1878

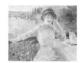

*Portrait of Alphonsine
Fournaise*
Oil on canvas, 71 x 92 cm
Paris, Musée d'Orsay
1879

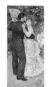

Dance in the Country
Oil on canvas, 180 x 90 cm
Paris, Musée d'Orsay
1883

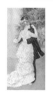

Dance in the City
Oil on canvas, 180 x 90 cm
Paris, Musée d'Orsay
1883

France

Nude amid Landscape
Oil on canvas, 65 x 55 cm
Paris, Musée de l'Orangerie
1883

Two Young Girls at the Piano
Oil on canvas, 116 x 90 cm
Paris, Musée d'Orsay
1892

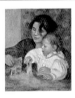

Gabrielle and Jean
Oil on canvas, 65 x 54 cm
Paris, Musée de l'Orangerie
c. 1895

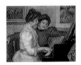

*Yvonne and Christine
Lerolle at the Piano*
Oil on canvas, 73 x 92 cm
Paris, Musée de l'Orangerie
1897

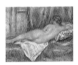

*Reclining Woman Seen
from the Back*
Oil on canvas, 41 x 52 cm
Paris, Musée d'Orsay
1909

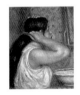

The Clown
Oil on canvas, 120 x 77 cm
Paris, Musée de l'Orangerie
1909

Reclining Woman
Oil on canvas, 67 x 160 cm
Paris, Musée de l'Orangerie
1910

*La toilette
(Woman Combing Her Hair)*
Oil on canvas, 55 x 46 cm
Paris, Musée d'Orsay
1910

Roses in a Vase
Oil on canvas, 29 x 33 cm
Paris, Musée d'Orsay
1910

Gabrielle with a Rose
Oil on canvas, 55 x 46 cm
Paris, Musée d'Orsay
c. 1911

France

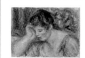

Woman Leaning on Her Elbow
Oil on canvas, 23 x 32 cm
Paris, Musée de l'Orangerie
1917-1919

The Great Bathers
Oil on canvas, 110 x 160 cm
Paris, Musée d'Orsay
1918-1919

Portrait of Stéphane Mallarmé
Oil on canvas
Versailles, Musée National des Châteaux
1892

Germany

Sisley and His Wife
Oil on canvas, 105 x 75 cm
Köln, Wallraf-Richartz-Museum
1868

Lise with Parasol
Oil on canvas, 184 x 115 cm
Essen, Museum Folkwang
1867

Great Britain

The Theatre Box
Oil on canvas, 80 x 64 cm
London, Courtauld Institute Gallery
1874

Portrait of Ambroise Vollard
Oil on canvas, 81 x 64 cm
London, Courtauld Institute Gallery
1908

Portugal

Madame Monet Reading
Oil on canvas, 53 x 71 cm
Lisbon, Museu Calouste Gulbenkian
*c.*1874

Russia

Under the Arbor at the
Moulin de la Galette
Oil on canvas, 81 x 65 cm
Moscow, The Pushkin State
Museum of Fine Arts
1876

Nude Woman Sitting
Oil on canvas, 92 x 73 cm
Moscow, The Pushkin State
Museum of Fine Arts
c.1876

Jeanne Samary
(La rêverie)
Oil on canvas, 56 x 47 cm
Moscow, The Pushkin State
Museum of Fine Arts
1877

Girls in Black
Oil on canvas, 80 x 65 cm
Moscow, The Pushkin State
Museum of Fine Arts
c.1881

La Grenouillère
Oil on canvas, 59 x 80 cm
St. Petersburg, The State
Hermitage Museum
1868

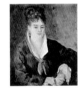

Woman in Black
Oil on canvas, 63 x 53 cm
St. Petersburg, The State
Hermitage Museum
c.1876

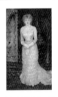

Portrait of the Actress Jeanne
Samary
Oil on canvas, 173 x 103 cm
St. Petersburg, The State
Hermitage Museum
1878

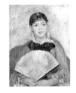

Girl with a Fan
Oil on canvas, 65 x 50 cm
St. Petersburg, The State
Hermitage Museum
1880

United States

The Luncheon at the
Riverbank
Oil on canvas, 55 x 66 cm
Chicago, The Art Institute
of Chicago
c.1879

On the Terrace
Oil on canvas, 100 x 80 cm
Chicago, The Art Institute
of Chicago
1881

United States		*Luncheon of the Boating Party* Oil on canvas, 129.5 x 17.25 cm Washington D.C., The Phillips Collection 1880-1882
Switzerland	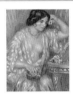	*Gabrielle à la rose* Oil on canvas, 82 x 166 cm Geneva, Skira Collection 1910

An excerpt from Renoir: An Intimate Record *by Ambroise Vollard*

RENOIR'S DRY MANNER

RENOIR: I was going to tell you last time, when Z. called, about a sort of break that came in my work about 1883. I had wrung Impressionism dry, and I finally came to the conclusion that I knew neither how to paint nor draw. In a word, Impressionism was a blind alley as far as I was concerned.

VOLLARD: But what about all the effects of light that you rendered so well?

RENOIR : I finally realized that it was too complicated an affair, a kind of painting that made you constantly compromise with yourself. Out of doors there is a greater variety of light that in the studio, where, to all intents and purposes, it is constant; but, for just that reason, light plays too great a part outdoors; you have no time to work out the composition; you can't see what you are doing. I remember a white wall which reflected on my canvas one day while I was painting; I keyed down the colour to no purpose— everything I put on was too light; but when I took it back to the studio, the picture looked black.

Another time I was painting in Brittany, in a grove of chestnut-trees. It was autumn. Everything I put on the canvas, even the blacks and the blues, was magnificent. But it was the golden luminosity of the trees that was making the picture; once in the studio, with a normal light, it was a frightful mess.

If the painter works directly from Nature, he ultimately looks for nothing but momentary effects; he does not try to compose and soon he gets monotonous. I once asked a friend, who was exhibiting a series of *Village Streets*, why they were all deserted.

"Because," he replied, "the streets were empty while I was at work."

VOLLARD: Corot painted all his life in the open, didn't he?

RENOIR : His studies, yes, but his compositions were done in the studio. He *corrected* Nature. Everybody used to say that he was wrong to work his sketches over indoors. I had the good fortune to meet Corot once and I told him of the difficulty I had working out of doors. He replied: "That's because you can never be sure of what you're doing. You must always paint over again in the

studio." But that did not prevent Corot from interpreting Nature with a realism that no Impressionist painter has ever been able to equal! How I have slaved to paint the colours of the stones of Chartres cathedral and the red bricks of the houses at La Rochelle as he did!

VOLLARD: Weren't the Old Masters working for these same effects of light? Duranty, I think, says that the Venetians foreshadowed them.

RENOIR: "Foreshadowed" is good! Just look at the Titians in the Prado. You don't even have to go back as far as Titian—take Ribera, a painter who has the reputation of being the last word in black. Do you remember the rose colour of the child and the yellow of the straw in his *Infant Jesus* in the Louvre? Have you ever seen anything more luminous than that?

VOLLARD: Allow me one last question. I read somewhere that "when we study the pictures in the museums—even those which exhibit the utmost science in the disposition of the planes, the use of perspective, the forms of clouds, the drawing of objects, the play of light, we observe one convention, or, rather, a lack of knowledge. In Ruysdael, and especially in Hobbema, the stippled, metallic foliage is the colour of ink. It is as if the sun had been blotted out."

RENOIR: Yes, but long before Ruysdael there were painters who filled their pictures with sunlight. Your author chooses his examples badly. In Italy, which is a warm country, Nature is more prodigal than in Holland. In the *Marriage at Cana* and the nudes of Titian, there is finer light than in any modern canvas.

VOLLARD: What about their landscapes?

RENOIR: Look at the *Villa d'Este* of Velásquez, or the *Concert Champêtre* of Giorgione, to mention only two. Even Rembrandt—would it ever occur to you to wonder whether his pictures were painted out of doors or in the studio?

I'm sick and tired of the so-called "discoveries" of Impressionism. It isn't likely that the Old Masters were ignorant of them; and, if they did not use them, it was because all great artists have despised mere effects. By making Nature simpler, they made it more impressive. For instance, if the magnificence of a sunset were permanent, it would wear you out, whereas the same scene, without that special effect of light is not at all fatiguing. With the ancient sculptors, action is reduced to a minimum. Yet you instinctively feel that their statues could move if they wanted to. When you look at Mercié's David, you almost want to help him put his sabre in its sheath!

I was looking at a nude on the easel, which had just been begun.

"From the way you talk, Monsieur Renoir, one would think that ivory black is the only colour that counts, but how do you expect me to believe that you painted flesh like that with 'mud'?"

RENOIR: I don't mean to compare myself with Delacroix, but do you remember that phrase of his, "Give me some mud, and I will paint you a woman's flesh"?

VOLLARD: But by that he meant it to be understood that the complementaries should be added, did he not? At least so the critics say.

RENOIR: Please don't ascribe things to Delacroix that he never even thought of! If he spoke of complementaries, it was probably when he was making experiments for a ceiling which had to be looked at from a distance. In that case, perhaps, you might reasonably speak of colours mixing in the eye of the beholder. The only thing I remember from the Journal of Delacroix, is that he is forever talking about red-brown. At the very mention of passing for an innovator, Delacroix would have [...]. Why, when he was painting the ceiling of the Chamber of Deputies, an employé of the library tried to compliment him by saying: "Master, you are the Victor Hugo of painting."

And Delacroix returned dryly: "You don't know what you're talking about, my dear friend! I am a classicist, pure and simple."

VOLLARD: Did you know that his distrust of innovation in art is also extended to music? Guillemet asked Corot one day what he thought of Delacroix. Corot replied: "A great artist! He's the greatest of them all! But there is one thing we have never been able to agree upon, and that is music! He doesn't like Berlioz—revolutionary music he calls it—and I feel very sorry for him."

RENOIR: I have told you how I discovered, about 1883, that the only thing worth while for a painter is to study the museums? I made this discovery on reading a little

book that Franc-Lamy picked up along the quays; it was a treatise on painting by Cennino-Cennini, and gave some precious information on the methods of the fifteenth-century painters.

The public is always convinced you are a fool if you abandon one style to which it is accustomed and adopt another; even my best friends complained of these new leaden colours of mine "after such pretty tones!" I had undertaken a large picture of *Bathers* and slaved away at it for three years. (The portrait of Mademoiselle Manet with a cat in her arms is also of this period.) The best that people could find to say about it was that it was a muddle of colour!

On the other hand, I must admit that some of my paintings of this period are not very soundly painted, because, after having studied fresco, I had fancied I could eliminate the oil from the colour. The surface then became too dry, and the successive layers of paint did not adhere well. I did not know at that time the elementary truth that oil-painting must be done with oil. Of course none of those people who established the rules of the "new" painting ever thought of giving us this precious hint! Another reason that induced me to dry the oil out of my colour was my search for a means of preventing the paint from blackening; but I later discovered that oil is the very thing which keeps colour from becoming black; only, one must know how to handle the oil.

At this time I also did some paintings on cement, but I was never able to learn from the ancients the secret of their inimitable frescos. I remember also certain canvases in which I had drawn all the smallest details with a pen before painting. I was trying to be so precise, on account of my distaste for Impressionism, that these pictures were extraordinarily dry.

After three years of experimentation, the *Bathers*, which I considered as my master work, was finished. I sent it to an exhibition at the Georges Petit Galleries (1886). I got roundly trounced for it, I can tell you. This time, everybody, Huysmans in the lead, agreed that I was a lost soul; some even said I was lazy. And God knows how I had laboured over it!

Apropos of the Exhibition at Georges Petit's, I might mention an article by Wyzewa, who was then the book-reviewer on the *Independent Review*. He wrote an article about my exhibition which was very comforting. I met Wyzewa shortly after, and through his good offices Robert de Bonnières later gave me a commission for a portrait of his wife. I can't remember ever having painted a picture which gave me more trouble! You know how I hate to paint skin that does not take the light! What was worse, it was the fashion then for women to be pale. And Madame de Bonnières, of course, was pale as wax. I used to say to myself: "If I could only get her to swallow a good beefsteak, just one!" No such luck! I worked at her home every morning until lunch-time, so I had a chance to see that they brought her to eat; a miserable little morsel in the center of the plate. […] Can you imagine *that* giving her colour? And such hands! She put them in cold water before each sitting, in order to increase her whiteness. If it hadn't been for Wyzewa, who spent most of the time cheering me on, I'd have thrown it all out of the window, brushes, colour-box, canvas—the whole infernal business! Fancy my getting one of the most charming women in the world to paint and—well, she simply refuses to have colour in her cheeks!

But when I say I have never done a portrait which annoyed me more, I am forgetting Madame Chartier, a beautiful young woman whose husband kept a little inn near Paris.

VOLLARD: I suppose her hands were used to housework, anyway.

RENOIR: Yes, but there were other things that were not so pleasant. She was not what you expect an innkeeper's wife to be, the placid and docile kind of woman I like to paint. On the contrary, she was fidgety and impatient. One day, more exasperated than usual, I shouted at her: "For God's sake, what's going on behind that face of yours!"

"Oh, *là là,* Monsieur, you're a nice one! I was just thinking that while I've been sitting here doing nothing, the stew has probably burned to a crisp!"

HOW I MADE THE ACQUAINTANCE OF RENOIR
I wanted to know who had posed for a Manet in my possession. It was a canvas representing a man seated on a camp-stool in a pathway of the Bois de Boulogne, wearing a grey hat, a mauve jacket, a yellow vest, white trousers, and varnished pumps—and I nearly forgot

to mention a rose in his buttonhole. I had been told that Renoir would know who it was, so I set out to look for him. I found that he was living in an old house in Montmartre called *The Château in the Mist.* In the garden I found a housemaid, dressed in bohemian fashion; she told me to wait, and pointed to the hallway of the house. Just then a young woman appeared, who was as buxom and amiable as one of those pastels by Perroneau of some good lady of the time of Louis XV. It was Madame Renoir.

"Oh, didn't the maid ask you to come in? […] Gabrielle!" The maid was taken aback by her mistress's tone of rebuke.

"But it's all muddy outside! And La Boulangère[1] forgot to put the mat back in front of the door!"

Madame Renoir went to call her husband, leaving me in the dining-room, where I found the finest Renoir's I had yet seen on the walls.

The painter soon came in. It was the first time I had ever seen him. He was a spare man, sharp-eyed, and very nervous, giving one the impression that he never stood still.

I explained the occasion of my visit.
"Your man is Monsieur Brun, a friend of Manet's," he said. "But we can talk better upstairs. Will you come up to the studio?"

Renoir showed me into the most commonplace sort of room. There were two or three badly matched pieces of furniture, a mass of colored stuffs, and some straw hats, which the painter was apparently accustomed to crumble in his fingers while posing the models. Canvases everywhere, stacked one against the other. Near the models's chair I observed a pile of copies—their wrappers unbroken—of *La Revue Blanche,* an "advanced" magazine very popular with the public. I remembered having read many a eulogy of Impressionist art in its pages.

"That is a very interesting magazine," I observed. "Yes, indeed," Renoir replied. "My friend Natanson sends it to me; but I must confess that I've never looked at the thing."

And as I reached out to pick up a copy, Renoir exclaimed: "Don't touch them! I put them there for the model to rest her foot on."

Renoir had sat down before his easel and opened his colour-box. I was amazed at the order and cleanliness of it: palette, brushes, tubes flattened and rolled up as they were emptied—all gave an impression of an almost feminine neatness.

I told the painter how delighted I had been with the two nudes in the dining-room.

"They are studies of the maids. Some of our servants have had admirable figures, and have posed like angels. But I must admit I'm not hard to please. I had just as lief paint the first old crock that comes along, just so long as she has a skin that takes the light. I don't see how artists could paint those over-bred females they call society women! Have you ever seen a society woman whose hands are worth painting? A woman's hands are lovely—if they are accustomed to housework. At the Farnesina in Rome there is a *Venus Supplicating Jupiter,* by Raphael. What marvelous hands and arms! She looks like a great, healthy housewife snatched for a moment from her kitchen to pose for Venus! That's why Stendhal thought that Raphael's women were common and gross."

My visit was cut short by the arrival of a model. I said good-bye and asked if I might come again.

"As often as you like! But come preferably towards evening when I have finished my work."

Renoir's existence was ordered like that of a bank employé. He went to his studio just as punctually as a clerk to his office. In the evening, after a game of chequers or dominoes with Madame Renoir, he went to bed early; he was afraid it would affect his work the next day if he stayed up late. All his life, painting was his only pleasure, his only relaxation.

I remember in 1911 meeting Madame Renoir as she was coming out of a hospital where Renoir was to be operated on.

"How is he getting along?" I asked.

"The operation has been put off until tomorrow," she replied. I'm afraid you will have to excuse me. I am in a great hurry […]. My husband has sent me to get his paints. He wants to do the flowers that were brought to him this morning."

Renoir worked at these flowers the entire day and all the next morning until it was time to go on the operating-table.

Another time in 1916 (Renoir had passed his seventy-fifth birthday), during the course of a visit to his home in Cagnes, I was struck by his sudden look of discouragement. I asked about the canvas he was then working on.

"There's no use, I can't paint," he answered. " I'm no good for anything any more." He closed his eyes desperately, and I went down into the garden for fear I was not wanted. A moment later I heard La Grande Louise[2] calling me.

"Monsieur Renoir wants you in the studio," she said. I found him at his easel, radiant. He was struggling with some dahlias.

"Look, Vollard, isn't that almost as gorgeous as a Delacroix battle-piece? I think this time I've got the secret of painting! […] What a pity that every bit of progress one makes is only a step towards the grave! If I could only live long enough to do a masterpiece!"

It is easy to imagine how eager I was to take advantage of Renoir's invitation to come again. The following week I came after dinner. This time he had just gone to bed! "I was all alone this evening," he explained, "so I went to bed earlier than usual. Gabrielle is going to read me *La Dame de Monsoreau.* You're invited to the party." But *La Dame de Monsoreau* could not be found.

"Well, then, Gabrielle," said Renoir, "see what there is in the library." Gabrielle opened a little book-case where twenty or more books were lying in a heap, and began reading the titles aloud: "*Cruelle Enigme, Peint par Eux-Mêmes, Lettres à Françoise, Les Confesisons d'un Amant, Deuxième Amour, Les Fleurs du Mal …*"

Renoir, interrupting: "I detest that book above all others! I have no idea who brought *that* here. If you had heard Mounet Sully (I think he was the one) recite *La Charogne,* at Madame Charpentier's, as I did […]. It's just as bad as the rest of the stuff Gabrielle was reading over. My friends are always trying to make me read a lot of rubbish."

Gabrielle continued: "*Mon Frère Yves, La Chanson des Gueux, Les Misérables…*" Renoir, who was listening indifferently, waved his hand in a gesture of annoyance on hearing this last title.

"They say that Hugo's poetry is very beautiful,"

I observed. "Anyone would be a fool to say that Hugo is not a man of genius," Renoir replied, "but as far as I'm concerned, I don't like him. The chief grievance I have against him is that he has got the French people out of habit of using simple language. Gabrielle, I want you to get me *La Dame de Monsoreau* to-morrow without fail."

Then, turning to me: "There's a masterpiece for you! […] The chapter in which Chicot blesses the procession is simply superb!"

"Oh, Monsieur Renoir! Cried Gabrielle suddenly. "I've found a book by Alexandre Dumas." Renoir's face brightened. "Good. Let's have a look at it."

But when Gabrielle announced triumphantly *La Dame aux Camélias,* Renoir exclaimed, "Never! I detest everything the younger Dumas wrote, and that book more than all the others. I have always had a horror of sentimental harlotry."

On top of the side-board in the dining-room, I saw a little coffee service and two porcelain candle-sticks, decorated by hand. Any industrious young girl might have painted them. I presumed that they were a gift of some kind. Renoir saw me looking at them.

"Those are the only souvenirs I have left of my china-painting days," he said.

And he proceeded to tell me something about his youth. It interested me so profoundly that I adopted the plan of asking the painter, every time I saw him, to tell me something about his life […].

[1] "The Bakery Girl," the nickname of one of Renoir's servants.
[2] An old servant of the Renoirs.

THE EXHIBITION OF THE IMPRESSIONISTS

RENOIR: When order was restored in Paris, I took a studio in the Rue Notre Dame des Champs. About the same time I got some decorations to do in the house of Prince Bibesco, which enabled me to spend the summer at Celle-Saint-Cloud. I did the *Henriot Family* there. On returning to Paris with the first cold weather, I commenced my big equestrian canvas, for which the wife of a certain Captain Darras had consented to pose. I sent it to the Salon and it was refused.

"I told you so," said Captain Darras triumphantly. "Now if you had only listened to me […]." The colour

had literally taken his breath away. While the sittings were going on, he was for ever saying: "Who ever saw a blue horse!"

But in spite of the sorry opinion he had of my painting, he was none the less of great service to me in every way. It was due to him, in his capacity of aid-de-camp to General Barrail, that I secured the Salle des Fêtes in the Military School to paint the picture in. *The Spring* and the *Mounted Trumpeter,* which has disappeared, were of about the same period.

It was in 1873 that one of the most important events of my life took place: I made the acquaintance of Durand-Ruel, the first dealer—the only one, in fact, for many a long year—who believed in me. At that time I left my studio in the Rue Notre Dame des Champs to go over to the Right Bank; but I instinctively foresaw the danger of absorbing too much of that atmosphere which Degas defined so well when he said: "No doubt Fantin-Latour's work is all right, but it is a little too Latin-Quarter!"

In 1873, feeling that I had really "arrived," I rented a studio in the Rue Saint-Georges. It was certainly a great success. The same year I went to Argenteuil, where I worked with Monet. I did quite a few studies there, among them *Monet Painting Dahlias.* At Argenteuil I also met the painter Caillebotte, the first "protector" of the Impressionists. He did not buy our pictures as a speculation. His sole idea was to help his friends as much as possible. And this he did admirably, for he took only the things which were unsalable.

VOLLARD: what about the exhibition organized in 1874 under the name of "Society of Painters, Sculptors and Gravers?"

RENOIR: The title in no way indicated the tendencies of the exhibitors; but I was the one who objected to using a title with a more precise meaning. I was afraid that if it were called the "Somebodies" or "The So-and-Sos" or even "The Thirty-Nine," the critics would immediately start talking of a "new school," when all that we were really after, within the limits of our abilities, was to try to induce painters in general to get in line and follow the Masters, if they did not wish to see painting definitely go by the board. "Getting in line" meant, you understand, relearning

a common craft. Except for Delacroix, Ingres and Courbet, who had flourished so miraculously after the Revolution, painting had fallen into the worst sort of banality. Everyone was busy copying everyone else, and Nature was lost in the shuffle.

VOLLARD: If it was as bad as that, Couture must have seemed like an innovator.

RENOIR: I should say so—almost a revolutionary! Those who flattered themselves on being "advanced" hailed Couture as their leader. His famous *Roman Orgy* had come on the scene in 1847 like a thunderbolt. They believed they had found in Couture a combination of Ingres and Delacroix, which the critics had vainly hoped for from Chasseriau.

VOLLARD: But how did the "Society of Painters, Sculptors and Gravers" become the "Impressionists"?

RENOIR: The name "Impressionists" came spontaneously from the public, who had been both amused and angered by one of the pictures on exhibition: an early morning landscape by Claude Monet entitled *Impression.* By the name "Impressionists," they did not intend to convey the idea of new researches in art, but merely a group of painters who were content to record impressions.

In 1877, when I exhibited once more with a part of the same group in Rue Lepeletier, it was I again who insisted on keeping this name "Impressionists" which had put us in the limelight. It served to explain out attitude to the layman, and hence nobody was deceived: "Here is our work. We know you don't like it. If you come in, so much the worse for you; no money refunded."

We were full of good intentions, but as yet were groping in the dark. Our struggles would have perhaps gone unnoticed, to the immense good of all, if it had not been for the critics and their "literature"—born enemies of the plastic arts. The public, even some of the painters themselves, were finally made to swallow a lot of nonsense about a "new art"! What on earth is the difference whether you paint in black and white, as Manet did under Spanish influence, or light upon light, as he did later under the influence of Claude Monet? Of course I do not mean to say that the artist's tempera-

ment has nothing to do with the method he employs. There is no doubt that Manet was surer of himself with black and white than with high-keyed colours.

VOLLARD: I have never heard of a single person who prefers Manet's dark manner to his light. But how did Manet come to be regarded as a pioneer, when his first canvases were so directly inspired by the galleries?

RENOIR: He was the first to establish a simple formula, such as we were all trying to find until we could discover a better.

VOLLARD: The "Impressionists" had less luck in 1877 than with their first exhibition in 1874, didn't they?

RENOIR: Yes, much less. The first exhibition was dubbed an art student's joke; the next time the public declared that the joke had gone too far. Perhaps if we had been shrewder we might have been able to conciliate the "connoisseurs" by painting subjects borrowed from history. What shocked people most of all was that they could find nothing in our pictures that was reminiscent of the galleries. To learn our craft, you see, we had to place our models in an atmosphere which was familiar to us. Can you see me painting a *Nebuchadnezzar* at a café table, or *The Mother of the Gracchi* in a box at the opera?

Nothing is so disconcerting as simplicity. I remember the indignation of Jules Dupré at one of our exhibitions. "To-day," he said bitterly, "one paints what one sees […]. One doesn't even prepare the canvas […]. Are these the great masters?"

VOLLARD: How *did* the "great masters" prepare their canvases?

RENOIR: Dupré was referring to the minium preparations so much in vogue with the Barbizon School. It was believed that preparing the canvas in this way gave "sonority" to the painting, which was quite true in principle; but the "great masters" of that time, for all their minium, only succeeded in producing work which lacked sonority, and which cracked all over into the bargain. What will pictures such as the *Angelus*[1] look like fifty years from now? The Duprés are already melting down over their frames.

What an amazing period that was! Those people spent three quarters of their time with their heads in the clouds. The subject had to crystallize in their minds before it could be put on canvas. One continually

heard such nonsense as: "The Master is overworking himself; he has been dreaming away in the forest for three days now!"

They couldn't even make a living with their literary pictures! Aside from a few like Dupré and Daubigny, and especially Millet, who were successful, what about the gang of poor devils who took the artist-legend of "dreamer" and "thinker" seriously, and sat with their heads in their hands in front of canvases that they never touched? You can imagine how those people scorned us because we were getting paint on our canvases, and because, like the old masters, we were trying to paint in joyous tones and carefully eliminate all "literature" from our pictures.

VOLLARD: Didn't the Impressionists allow themselves to be too much influenced by foreign schools? Japanese art, for instance?

RENOIR: Unfortunately, yes, in the beginning. Japanese prints are certainly most interesting, as Japanese prints… that is to say, on condition they stay in Japan. No people should appropriate what does not belong to their own race, if they don't want to make themselves ridiculous. If they do, they produce nothing but a kind of bastard art, with no real character. Certain critics are beginning to claim me as a true member of the French School. I am glad of that, not because I think that that school is superior to others, but because, being a Frenchman, I ought to represent my own country.

[1] I arrived one day at Lewis Brown's (about 1888) to find him in a state of great excitement. "I used to know Millet's *Angelus* when it was all cracked from top to bottom," he declared. "And now I have just seen it again, and it looks like new." But recently (1920) a newspaper again raised the alarm that the *Angelus* was "beginning" to crack. So much for the work of the picture-restorers. (Author's Note.)

THE IMPRESSIONIST THEORIES

I had been wanting for a long time to know what Renoir thought of the theories of Impressionism; but I was positive that if I were to ask him bluntly, he would reply at once: "Oh, don't bother me!" Therefore I set about reading what the critics of modern art had written on the subject, and, taking note of the state-

ments which had struck me as most significant, I said one day: "The modern painters are very fortunate to have colours that the ancient never even dreamed of!"

RENOIR: fortunate ancients, you mean; they had only the ochres and browns. What a pretty spectacle progress is anyway!

VOLLARD: At least you cannot deny that the Impressionists have made real progress by discarding "flat tones, which destroy transparency."

RENOIR: Who told you that flat tones destroy transparency? That sounds like Père Tanguy.[1] He thought that you had to paint "thick" to be modern.

At first I was tempted to reply that I had got it from a book of advanced modern criticism;[2] but I thought it would be more prudent not to mention it. However, I continued: "Then the only innovation of Impressionism, so far as technique is concerned, is the elimination of black, the non-colour?[3]

RENOIR: (startled): Black a non-colour? Where on earth did you get that? Why, black is the queen of colours! Wait. Look in that *Lives of the Painters.* Find Tintoretto. Here, give me that book!

(He read) "When Tintoretto was asked what his favorite colour was, he replied: 'The most beautiful of all colours is black.'"

VOLLARD: How is that, when you have substituted Prussian blue for black?[4]

RENOIR: Who told you so? I have always had a horror of Prussian blue. Once I tried to use a mixture of red and blue instead of black, but then I used cobalt-blue or ultramarine, only to come back in the end to ivory-black. […]

VOLLARD: Then Turner, in his "luminous" period, was the only one before Monet who used prismatic colours?

RENOIR: Turner? Do you call that luminous?—just like bon-bon colours […]. It would be exactly the same thing if he painted with his morning chocolate!

VOLLARD: But Claude Monet and Pissarro were Turner's disciples, were they not?

RENOIR: Pissarro tried a little of everything, even *petit point,* but he gave it up like the others. As for Monet, someone told me that on returning from one of his trips to London, he said: "Turner makes me sick!"

The only man who influenced Monet was Jongkind. He was Monet's point of departure.

I can give you a personal example of influences in painting. At the beginning, I used to put paint on thick, thinking I would get more "value" that way. One day, at the Louvre, I noticed that Rubens had obtained more by a simple rubbing than I did with all my heavy layers. Another time, I discovered that Rubens produced a silver with black. I learned my lesson, of course; but does that necessarily mean that I was influenced by Rubens?

(I began to ask myself if all the things that had impressed me so much were not simply "literature." I made one last try): At any rate, the Impressionists excel in "painting by chance sensations and by the powerful clairvoyance of instinct […]."[5]

RENOIR: (interrupting): "Chance sensations"! "Power of the instincts"! Like the animals, eh? That sounds like the fools who congratulate us on giving our models "expressive poses."[6] Those good people do not realize that Cézanne called his compositions souvenirs of the museums; for my part, I have always tried to paint human beings just as I would beautiful fruit. Look at the greatest of modern painters, Corot, and see if his women are "thinkers." But if you try to tell those people that the most important thing for a painter is to know good colours, just as the mason ought to know the best mortar—[7] And the first Impressionists worked away without ever even thinking of a sale! It is the only thing our imitators have forgotten to copy. (I saw a little book on the table with the pages still uncut, called *The Laws of Impressionism, a Selection from the Masters of Criticism.*)

RENOIR: Always this mania for imposing a lot of rigid formulae and processes on the painter! To conform with the rules, we would all have to have the same palette—socialism in art, eh? Painting in twenty-five lessons! (I had started to turn the pages of *The Laws of Impressionism,* and I read aloud: "Manet died before he was able to take advantage of the luminosity derived from the division of tones."[8])

RENOIR: He was lucky to have died in time.

VOLLARD: (continuing to read): "The majority [of Impressionists], especially gifted artists, would

certainly have left glorious works, even if they had kept to traditional methods."[9]

RENOIR: (silencing me with a motion of his hand): But it was just when I was able to get rid of the Impressionist theories, and came back to the teaching of the museums [...]. (He gave a slight shrug.)

VOLLARD: So even the best of the Impressionist "theories" is simply literature "putting the hooks into painting," as Cézanne would have said. But you cannot deny that certain painters profited by Chevreul's work on the spectrum. Now when the Neo-Impressionists applied their scientific discoveries [...].

RENOIR: Their what?

VOLLARD: You know what I mean, pure tones juxtaposed...

RENOIR: Ah, yes, *petit point*. Octave Mirbeau took me one day to see an exhibition of that. But the worst of it was that, on entering, you were informed that to be able to tell what the pictures represented, you must stand two and a half yards away from them. You know how I love to walk close to a picture, and even take it in my hands! You remember the large picture by Seurat, *Models in a Studio,* that we saw together—a canvas painted in *petit point,* the last word in science! [...] Do you remember the chap beside me who said: "What difference does it make how the picture turned out, so long as the artist enjoyed doing it?"

Can you imagine Veronese's *Last Supper* painted in *petit point?*

But when Seurat paints without tricks! [...] You know those little canvases of his, unpretentious, no "pure tones"; how beautifully they are preserved.

The truth is that in painting, as in the other arts, there's not a single process, no matter how insignificant, which can reasonably be made into a formula. For instance, I tried long ago to measure out once and for all, the amount of oil which I put in my colour. I simply could not do it. I have to judge the amount necessary with each dip of the brush. The "scientific" artists thought they had discovered a truth once they had learned that the juxtaposition of yellow and blue gives violet shadows. But even when you know that, you still don't know anything. There is something in painting which cannot be explained, and that something is the essential. You come to nature with your theories, and she knocks them all flat.

The door bell rang. "Is Monsieur Renoir at home?" I got up to go.

RENOIR: You can stay; I recognize the voice. It is Z. You know, he is the only one at the Beaux Arts who likes what we are doing, except, of course, Roger Marx. (I congratulated Monsieur Z. on the courage with which he was batting for modern art, risking, at every turn, his excellent position of chief Under-Inspector at the Ministry.)

Z.: Behold a man who has not yet wasted his day! By going over the head of my minister, I have just succeeded in obtaining from the Ministry of Commerce the formal promise of a *rosette* for Ernest Laurent. His "open air indoors" is doing more than anything else to popularize Impressionist art.

(When he had left the studio, I echoed: "Open air in doors"!)

RENOIR: The popularization of art, indeed! That's enough to make you give it all up! Fortunately there is no stupidity in the world that can make a painter stop painting.

[1] For further information about Père Tanguy, see *Paul Cézanne, His Life and Art,* by Ambroise Vollard, translated by Harold L. Van Doren. (Nicholas L. Brown, New York, 1923)

[2] Georges Lecomte, *Impressionist Art,* Chamerot and Renouard, Paris, 1892, page 22.

[3] *Ibid.,* page 16.

[4] Camille Mauclair, *Impressionism (Libraire de L'Art Ancien et Moderne),* Paris, 1904, page 117.

[5] Georges Lecomte, *Impressionist Art,* page 22.

[6] See Appendix I, A.

[7] Monsieur Mauclair does not approve of the tendency of the Impressionists "to insist on a painter's being, above all, a good craftsman."

[8] Georges Lecomte, *Impressionist Art,* page 27.

[9] *Ibid.,* page 24.

Concise Bibliography

Bailey, Colin. *Renoir's Portraits: Impressions of an Age.* New Haven: Yale University Press, 1998.

Benjamin, Roger. *Renoir and Algeria.* New Haven: Yale University Press, 2003.

Callen, Anthea. *The Art of Impressionism: Painting Technique and the Making of Modernity.* New Haven: Yale University Press, 2001.

Herbert, Robert L. *Impressionism: Art, Leisure, and Parisian Society.* New Haven: Yale University Press, 1991.

Renoir, Jean. *Renoir, My Father.* Trans. Randolph and Dorothy Weaver. New York: The New York Review of Books, 2001.

Vollard, Ambroise. *Renoir: An Intimate Portrait.* Trans. Harold L. Van Doren and Randolph T. Weaver. New York: Alfred A. Knopf, 1925.

White, Barbara Ehrlich. *Renoir: His Life, Art, and Letters.* New York: Harry N. Abrams, 1988.